UNFAMILIAR JOURNEYS

unfamiliar journeys

photographs by Alan McKernan

THE UNIVERSITY
of LIVERPOOL

Published by the University of Liverpool Art & Heritage Collections
to accompany the exhibition
unfamiliar journeys
photographs by Alan McKernan

6 April - 28 July 2006
University of Liverpool Art Gallery
3 Abercromby Square, Liverpool L69 7WY

ISBN Number 184 631 029 6
distributed by Liverpool University Press

Design: Vivienne Palfreyman

preface

The University of Liverpool is delighted to support the publication of this important series of photographs by Alan McKernan. Alan has been actively documenting the changing face of Liverpool since the late 1990s, and this series of one hundred images has been selected from a body of many thousands of prints.

In an age when digital photography is widely affordable, it is interesting to see examples in the traditional black and white medium. Here images have been made using only natural light, and then hand printed by the photographer. To an extent this series follows the work of another noted Liverpool photographer, Edward Chambre Hardman, who in the 20th century recorded Liverpool's changing landscape. However, where Hardman focused on people at least as much as scenes, Alan McKernan presents a view of the city uncluttered by people or cars. It is remarkable that McKernan achieves these images by simply waiting for the best moment to capture the buildings and surrounding landscape, rather than by manipulating his works through digital technology.

This book is an overview of the many themes of interest to McKernan. Iconic city buildings, including the cathedrals, St George's Hall, the Philharmonic Hall, the Albert Dock and the Town Hall are featured. But also to be found are more unusual views of the city, some of which may not be familiar even to the lifelong inhabitant. In both cases, the work will, I hope, appeal as much to the visitor to Liverpool as to the habitué.

The book comes at a time when Liverpool is undergoing a period of major change. As Joseph Sharples notes in his essay '*the process in Liverpool is arguably faster paced, more extreme, more visually arresting – and more photogenic – than anywhere else* [in the country]'. McKernan's work not only documents the process of this change, and in some cases records the destruction of buildings to make way for the new, but it also offers a view of how the past, present and future elements create the city we know today. In the build up to Liverpool's celebration of its status as European Capital of Culture in 2008, McKernan's timely series of photographs shows us the developments the city has made in the immediate past.

This is a series of images to enjoy, and I hope you gain as much pleasure from them as I have.

Drummond Bone
Vice-Chancellor
The University of Liverpool

the changing face
of liverpool

The photographs in this book show Liverpool during a period of transformation unprecedented since the expansive 1960s. After decades in the economic doldrums, during which the city's fabric was ravaged by neglect and decay, Liverpool in the last few years has experienced a return of self-confidence and investment, and with this has come a remarkable building boom. The fashion for city-centre living that took off in Manchester in the 1990s has belatedly gripped Liverpool too, and residential blocks are springing up everywhere. Most strikingly, a great swathe of what was once, before wartime bombing, part of the business district, is being rebuilt as an extension of the shopping area. One of the ironies of this process is that as high-rise living for the well-off transforms the downtown skyline, an earlier generation of failed council housing tower blocks in the inner suburbs is being demolished. The pace of change is extraordinary, and is vividly illustrated in these pages. Clusters of cranes loom above construction site hoardings, while shiny new apartment blocks colonise tracts of derelict dockland. The past – nineteenth-century terrace or twentieth-century tower block – is reduced to rubble or awaits the bulldozer. Some indestructible landmarks remain, but their familiar settings are transformed, and in distant views they are oddly framed by upstart newcomers. Some of the photographs show scenes uncannily – and disturbingly – similar to the Liverpool of the 1960s, the era of comprehensive redevelopment, with its appetite for destructive and disorientating replanning, soulless architecture and domineering road schemes.

Alan McKernan's photographs are not easy to pigeon hole. On the one hand they have something in common with a long tradition of topographical art recording the changing face of Liverpool, beginning in the nineteenth century with the Herdman family of watercolourists. At the same time they are part of a more recent tradition that sees a kind of melancholy beauty in the gritty reality of the urban scene, a tradition that includes the films of Terence Davies and the photographs taken by Graham Smith and David Wrightson for Quentin Hughes's 1964 book, *Seaport*. Something that sets McKernan's work apart from both these, however, is its cool detachment and apparent lack of sentiment, most obvious in the deliberate omission of any human presence: people are nowhere to be seen, and even cars are hard to find. This ghost-town quality can give a bleak, even sinister air to scenes of decay and reconstruction alike. The stark pattern of cast shadows is often emphasised, and buildings shown sharply tilted from the vertical, so that the photographer seems more interested in the abstract geometry of the urban landscape than in the life and activity associated with these places. At the same time, the pictures are not without humour. The juxtaposition of grandeur and squalor, of new and old, is wryly observed, and here and there the wording of street signs and advertising hoardings provides a droll commentary on the surrounding scene. It is not clear if

McKernan intends to pass judgment on the changes to which his camera bears witness, but his pictures do not seem to offer a whole-hearted endorsement of Liverpool's 'retail-led regeneration'.

Some of the photographs show familiar historic landmarks in all their glory – the cathedrals, the Pier Head, the civic forum around William Brown Street – while others provide a record of interesting buildings that have since been demolished, or new buildings of merit. For the most part, however, this is not simply a documentary record of Liverpool architecture, still less a celebration. The images are almost always surprising and intriguing, and sometimes seem calculated to baffle or mislead the viewer. Low view points give unexpected prominence to foreground features, so that the Royal Liver Building and the Metropolitan Cathedral, for instance, appear to rise from wooded hills, and the University's Victoria Building looks as if it stands on a monumental stepped terrace. St George's Hall is not presented in its familiar role as a 'heritage' icon, but serves as a backdrop to a tangle of traffic lights and pedestrian barriers. Road markings, patched tarmac, street signs and security cameras – the banal foreground clutter of urban life – are here just as prominent as architecture, but are composed by the photographer with scrupulous care and discipline.

This is not a conventional picture book of Liverpool's architectural riches – though anyone who looks through its pages will recognise that this is a city of exceptional buildings with a remarkably strong visual character – but rather a reflection of momentous urban changes. Similar changes are happening in other British cities, but as in the nineteenth century, the process in Liverpool is arguably faster paced, more extreme, more visually arresting – and more photogenic – than anywhere else.

Joseph Sharples

on a city? true light

The title *unfamiliar j ourneys* highlights a unifying theme in this series of images by the Liverpool born and based photographer Alan McKernan. The universally familiar face of the city, seen in the cathedrals and St George's Hall for example, is re-presented through vistas previously unseen. The Cathedral of Christ the King appears perched on a wild heath, whilst the Anglican Cathedral is glimpsed through the terraces which sit on its eastern side. The unfamiliarity here stems not from the subject, but from the viewpoint. In views of the housing, pubs and diverse buildings which make up the wider city, McKernan takes the viewer on a more obvious journey into areas generally unknown. The terraces in the north of the city and the more recent high rise developments in and around the docklands are carefully documented, and this enables a less recognized facet of the city to be brought to life.

In his essay Joseph Sharples notes that McKernan's work is hard to define. It is possible to identify recurrent areas of interest, and techniques of composition. McKernan enjoys capturing architectural views which are very sculptural, in which the building elements, often highlighted by shadow, form strident geometric patterns. Examples include the Daily Post and Echo building (page 34), which appears as giant building blocks piled high, the images of boarded buildings, and the treatment of many of the recent city centre developments, (page 75 and page 99). This technique highlights forms which are not immediately obvious, and thus further develops the wider theme of the unfamiliar. A related interest is in the skeletal structures of buildings under construction. These are presented as both interesting (and temporary) objects, and at times monstrous intrusions (page 73).

Sharples has also discussed McKernan's use of fore-shortening, and the manipulation of perspective. This is an element of the photographer's wider interest in the dramatic. At a basic level this stems from the medium itself: black and white photography has an innate quality of drama which McKernan's style emphasises. It is particularly apparent in images with very strong lighting contrasts: the Mersey tunnel ventilation shaft emerging from darkness (page 88), the Dale Street flyover shown as a black ribbon (front cover and page 16), a simple wall shown as a black mass (Moss Street, page 44). The interest finds more subtle manifestation in the production of images reminiscent of black and white film sets. In images such as Philharmonic Hall (page 62) and Tower Building (page 31) the city is transformed into an American film set, missing only the period cars and costumes. At times this drama is tempered with a humorous eye, for example in Bling Bling (page 43) and Kerb crawlers (page 44).

Any attempt to define aspects of McKernan's photographs inevitably leads to consideration of whether he adopts a definite point of view towards the city. Is this a celebration of a vibrant city, a

document of changing architecture, or a commentary on social and political issues? The conscious decision to photograph Liverpool devoid of inhabitants perhaps offers a clue. The result is a picture of the city landscape as one almost never sees it: the photographer can claim it is a genuinely honest appraisal of the urban environment that has resulted from the years of neglect followed by a period of startling development. It is up to the viewer to decide how far McKernan's style and choice of subject renders this appraisal subjective.

Matthew H Clough
Director, Art & Heritage Collections

artist's statement

As a photographer, I've long been fascinated by, and experimented with, the ever-changing quality of light as it plays upon the landscape; sculpting and re-defining it. The challenge I set myself commencing in 2000, was to celebrate those ephemeral qualities of light, by utilising traditional photographic materials.

Having distanced myself from the immediacy of contemporary consumerist digital photography, I've engaged with traditional black & white silver-based negative film to record my alternative images of Liverpool.

By comparison with the casual capture of a digital image, the production cycle I use is slow and deliberate. I begin with careful observation of the subject matter over time. Progression to the camera work follows only when I consider the lighting conditions will enable the drawing on negative film of the landscape qualities that I wish to re-present to the viewer. The conjuring of the light-drawn image is then continued into the darkroom. My revival of the specialist craft skills of hand-printing enables me to harness the power of light a second time; firstly with the camera, secondly with the enlarger in the darkroom. In this way I am able to personalise the interpretation of the negative, with the production of the final silver-gelatin print.

Alan McKernan

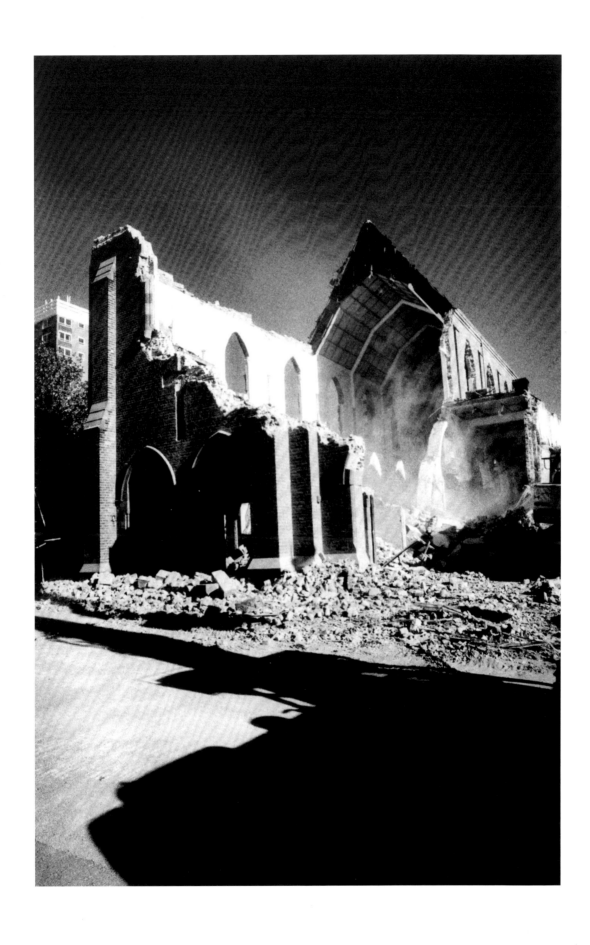

Demolished church, Great Crosshall Street, [now site of Focus apartments] : Autumn 2003

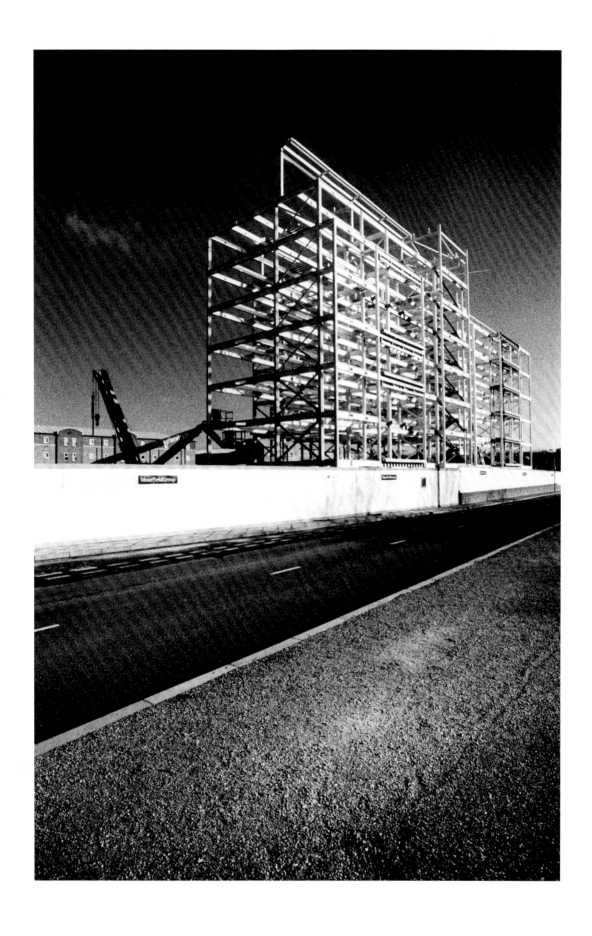

Construction, Leeds Street : Spring 2005

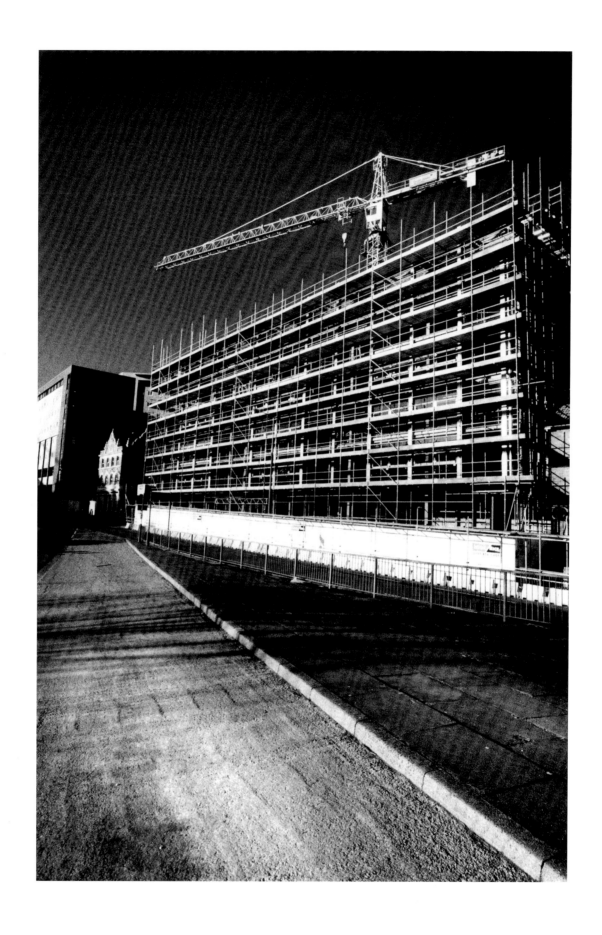

Focus apartments development, Great Crosshall Street : Winter 2004

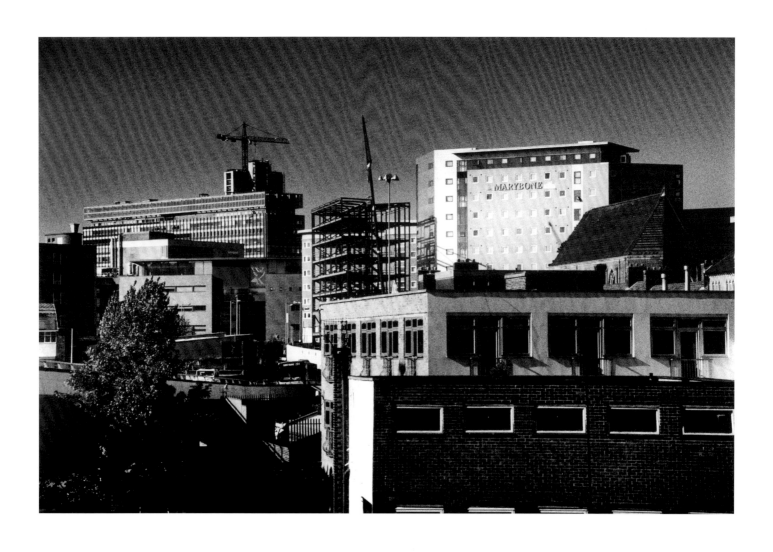

Marybone area from Byrom Street : Autumn 2003

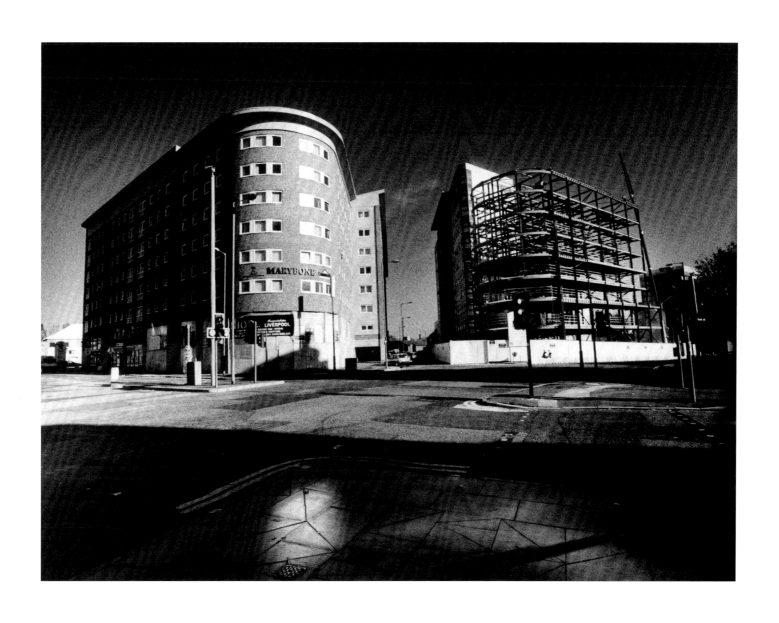

Junction of Marybone & Great Crosshall Street : Autumn 2003

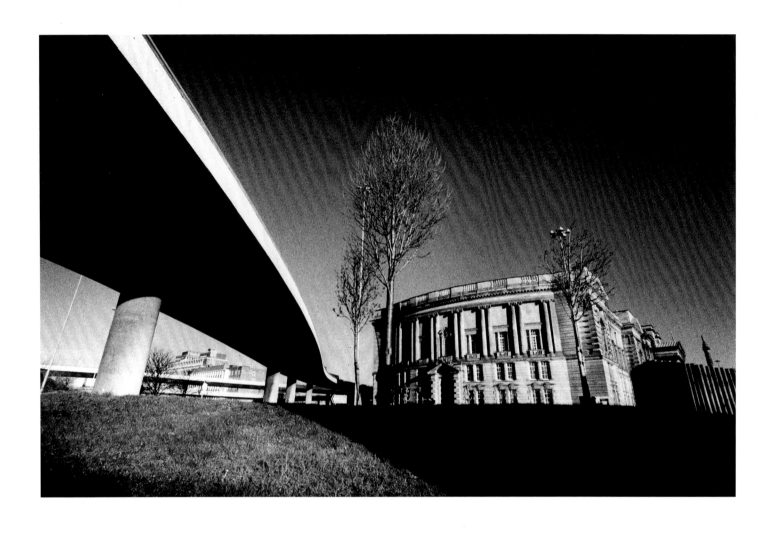

Dale Street Flyover : Winter 2003

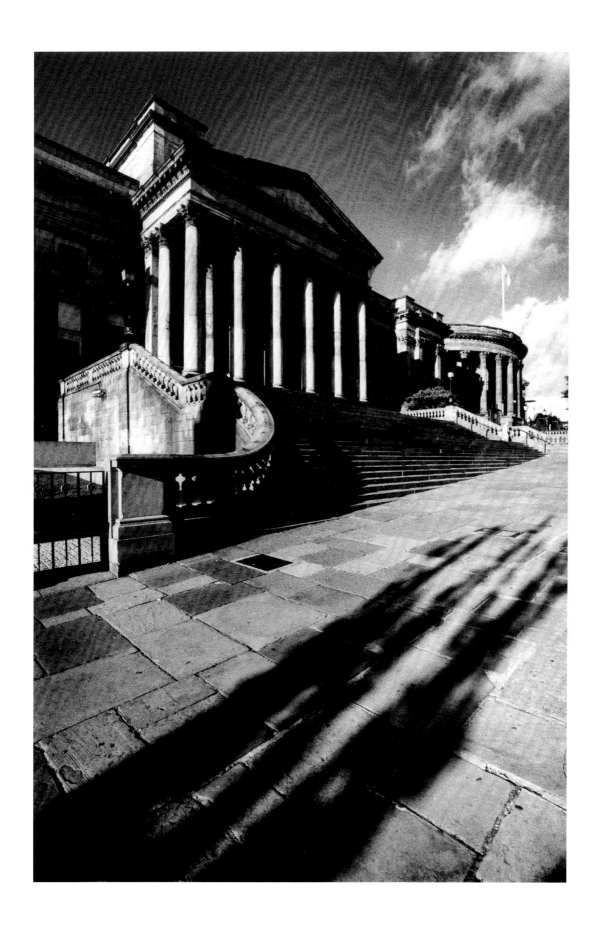

World Museum, Liverpool : Summer 2005

William Brown Street, across to Lime Street : Summer 2005

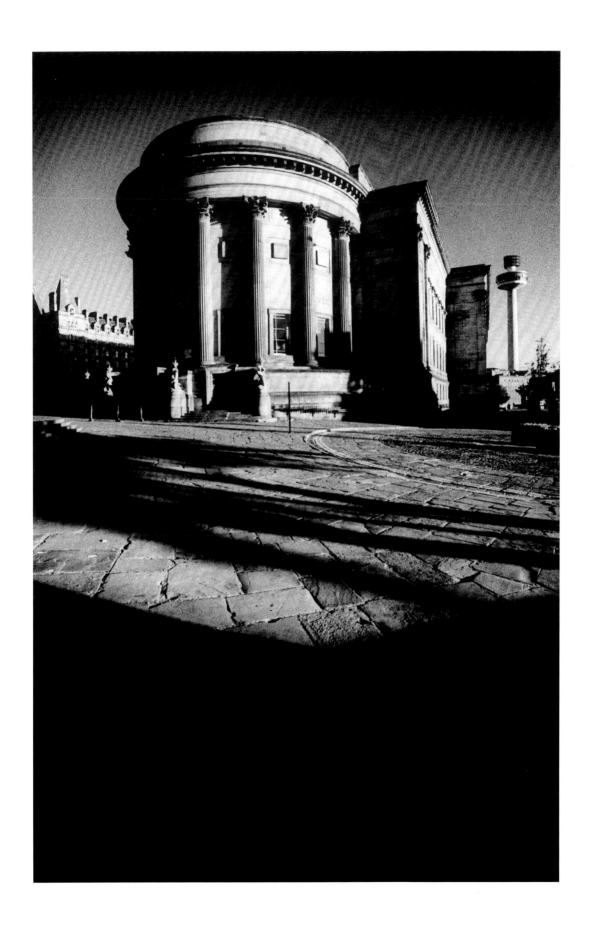

St George's Hall from William Brown Street : Summer 2002

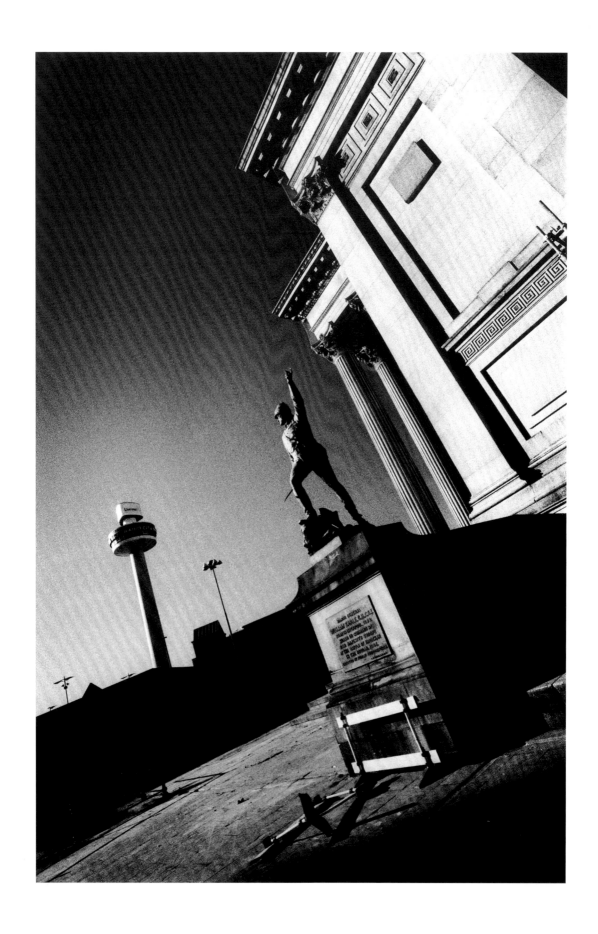

St George's Hall Plateau : Winter 2005

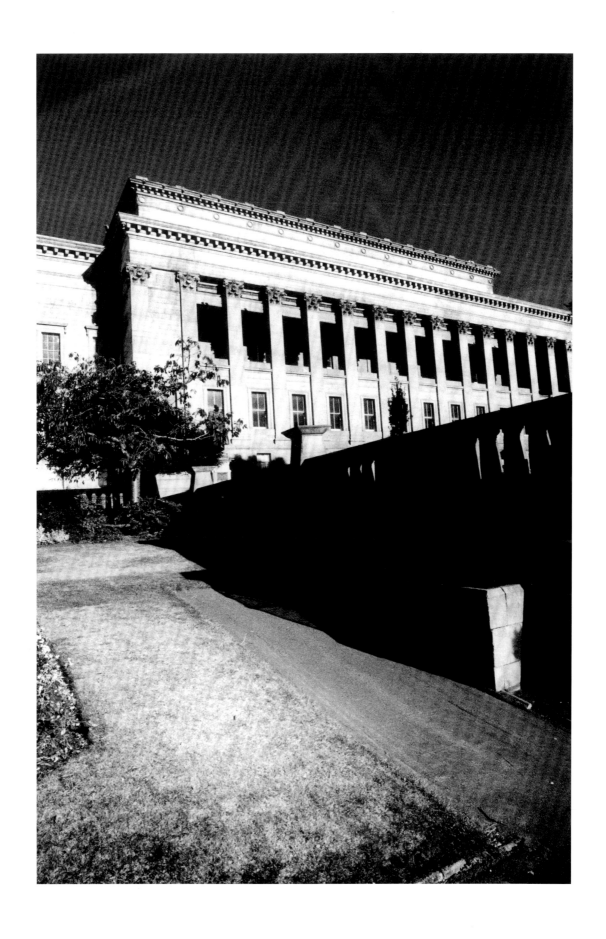

St John's Gardens and rear of St George's Hall : Summer 2005

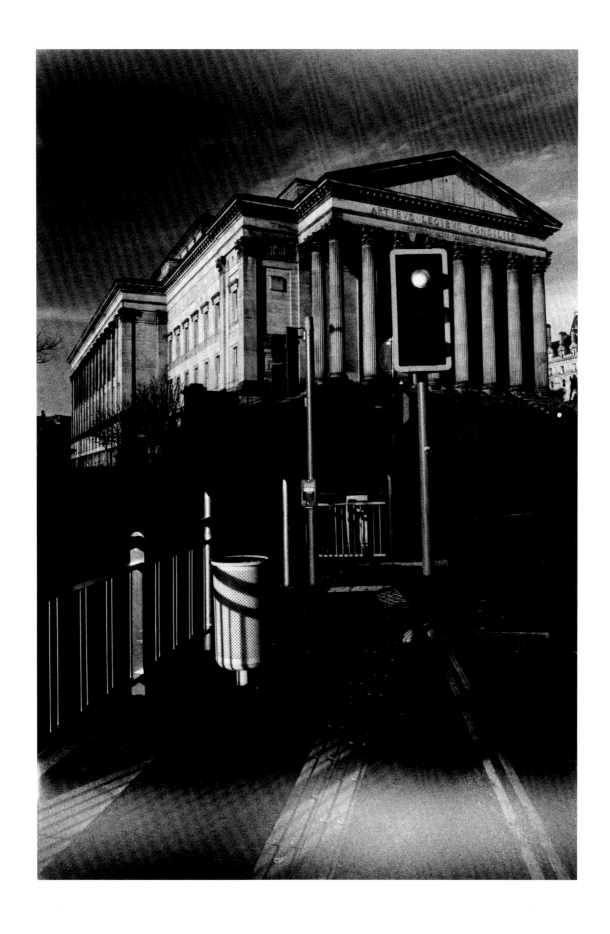

St George's Hall : Winter 2001

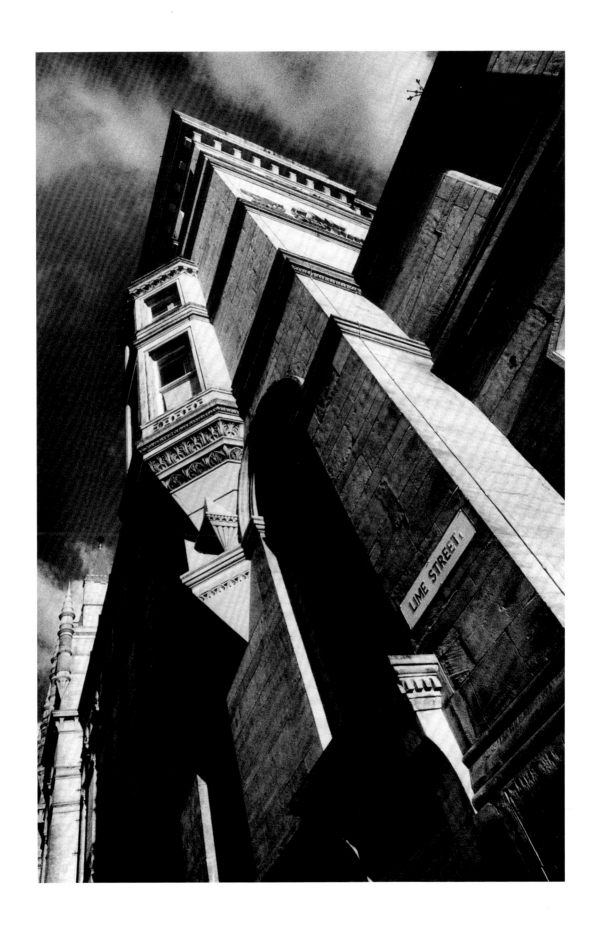

Lime Street : Winter 2002

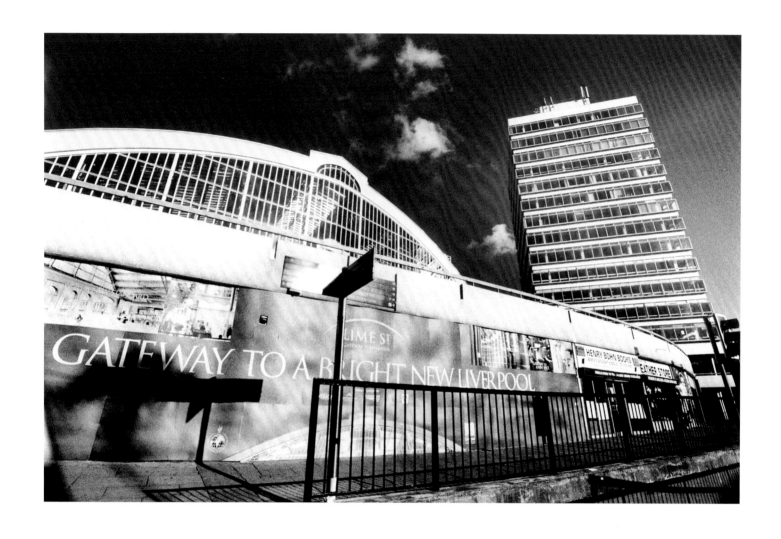

Lime Street Railway Station : Summer 2005

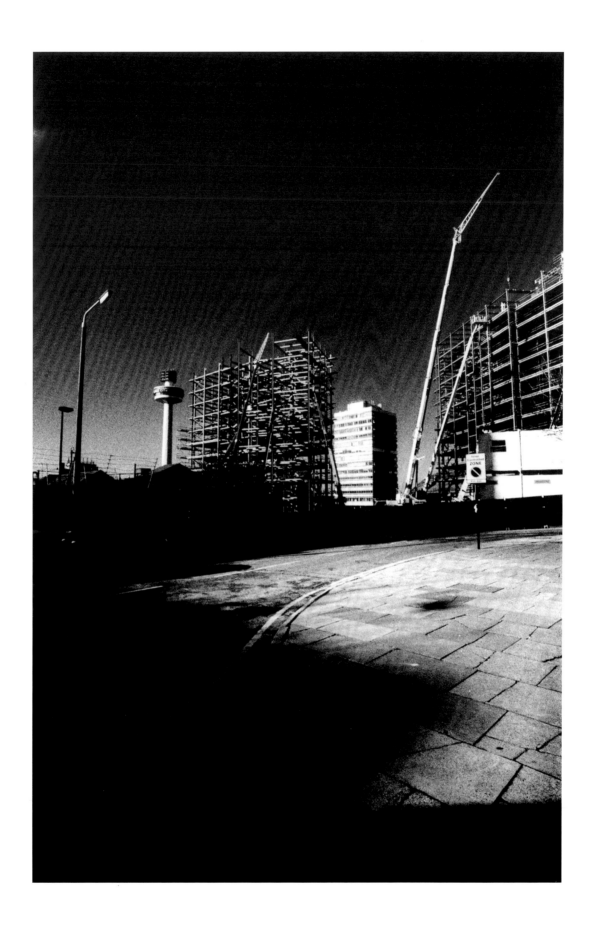

Construction of student accommodation, Lime Street area : Winter 2003

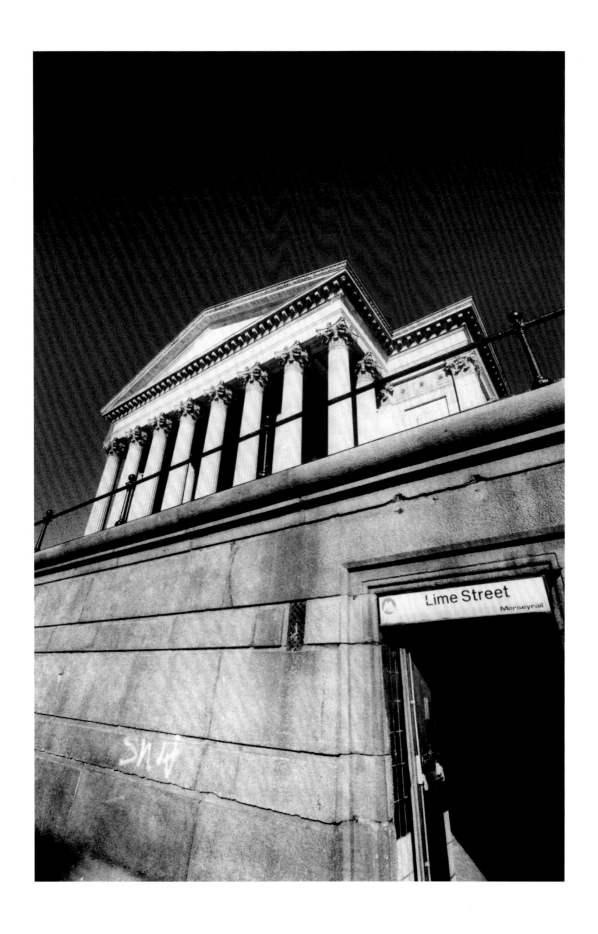

Pedestrian Underpass, St George's Hall : Winter 2005

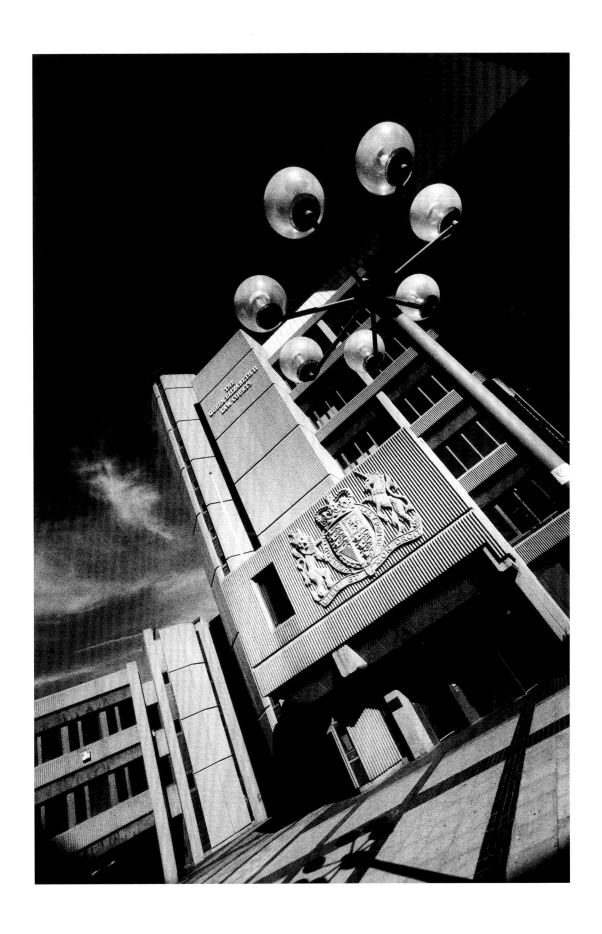

The Queen Elizabeth II Law Courts : Summer 2005

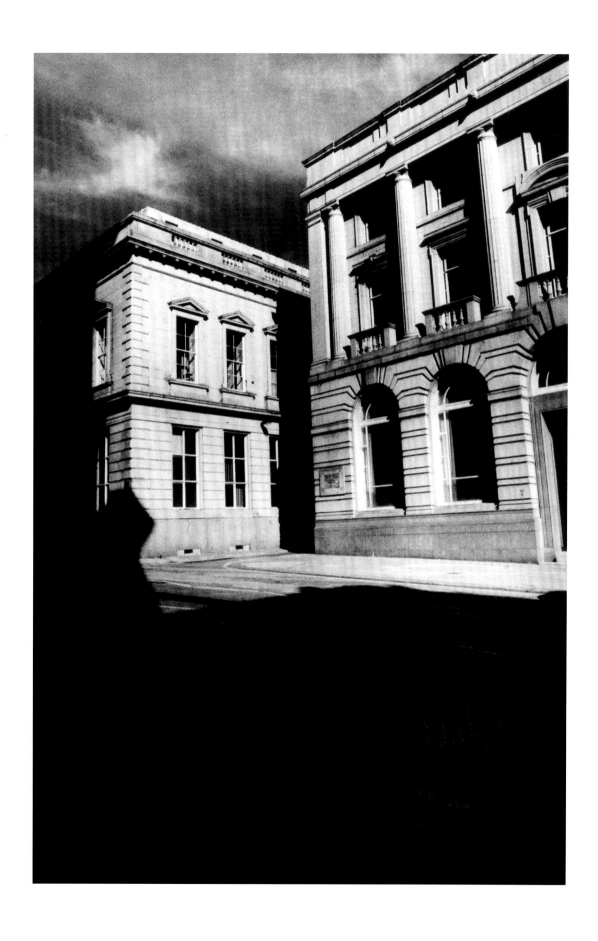

Dale Street : Summer 2005

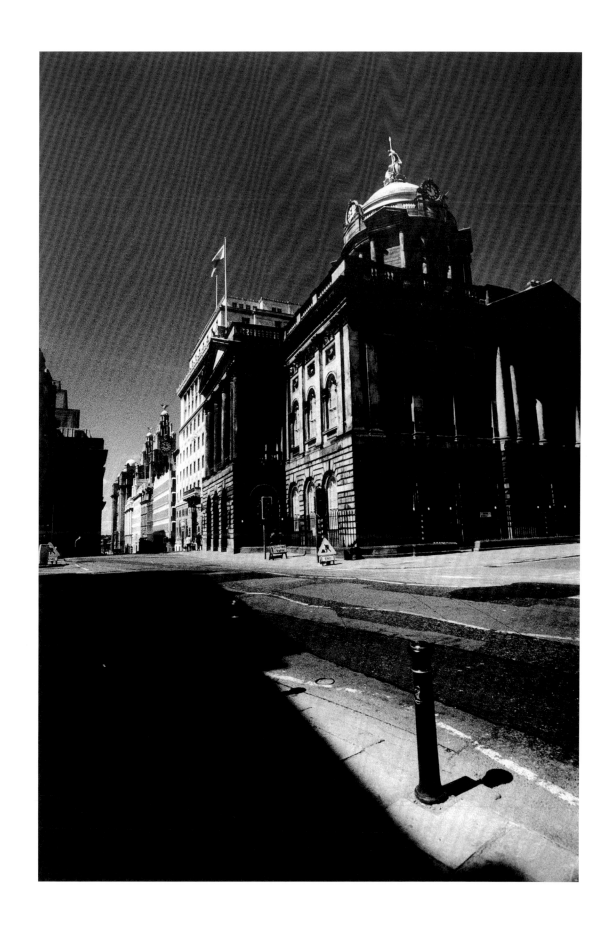

Liverpool Town Hall and Water Street : Summer 2005

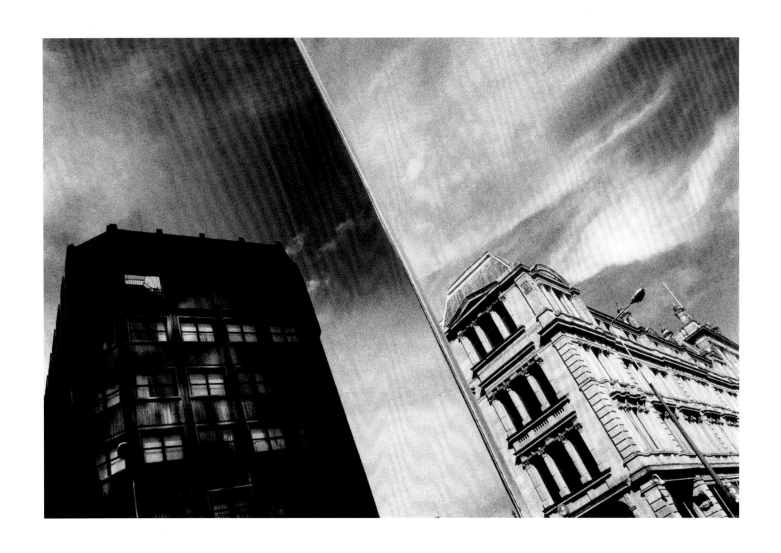

Reflections in glass, Chapel Street : Spring 2001

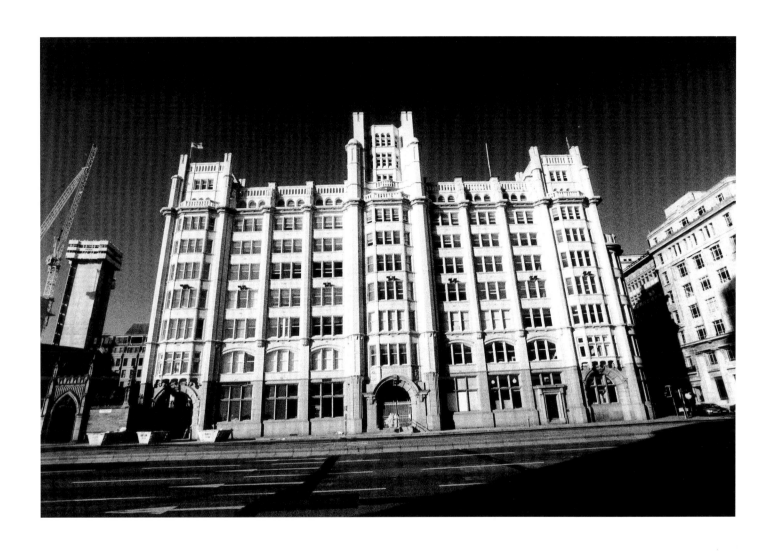

Tower Building, New Quay : Summer 2005

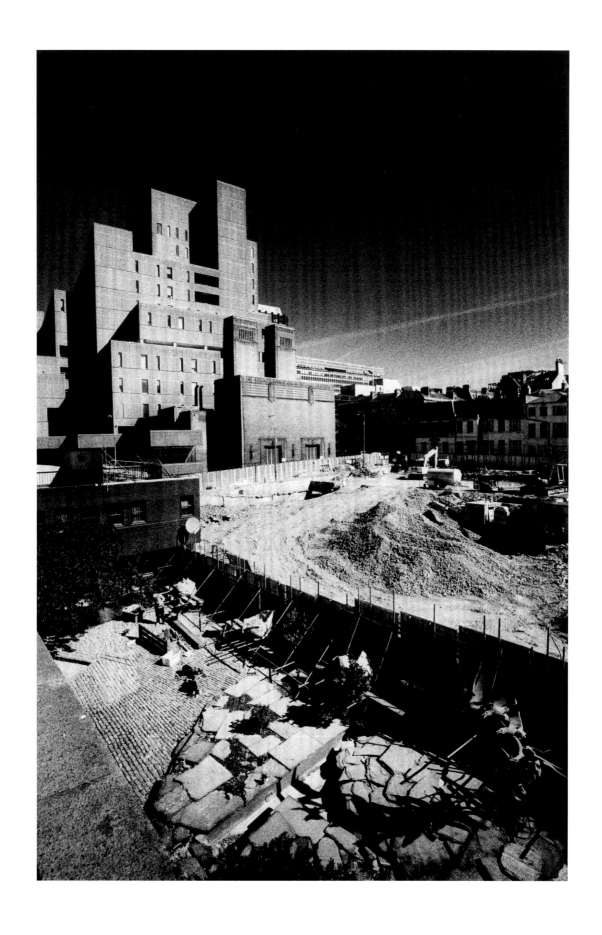

Site of Unity apartments development, Chapel Street : 2004

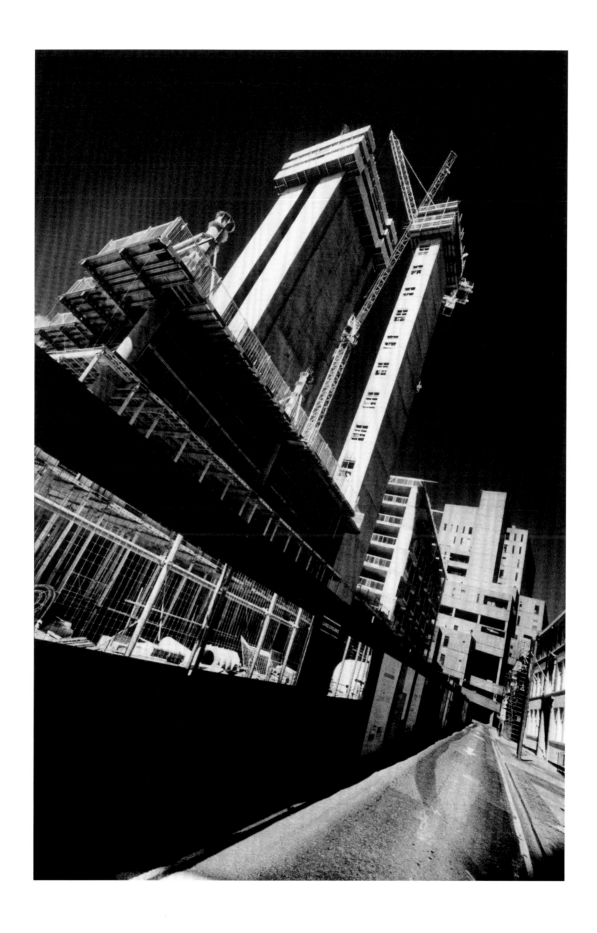

Unity apartments development, Chapel Street : 2004

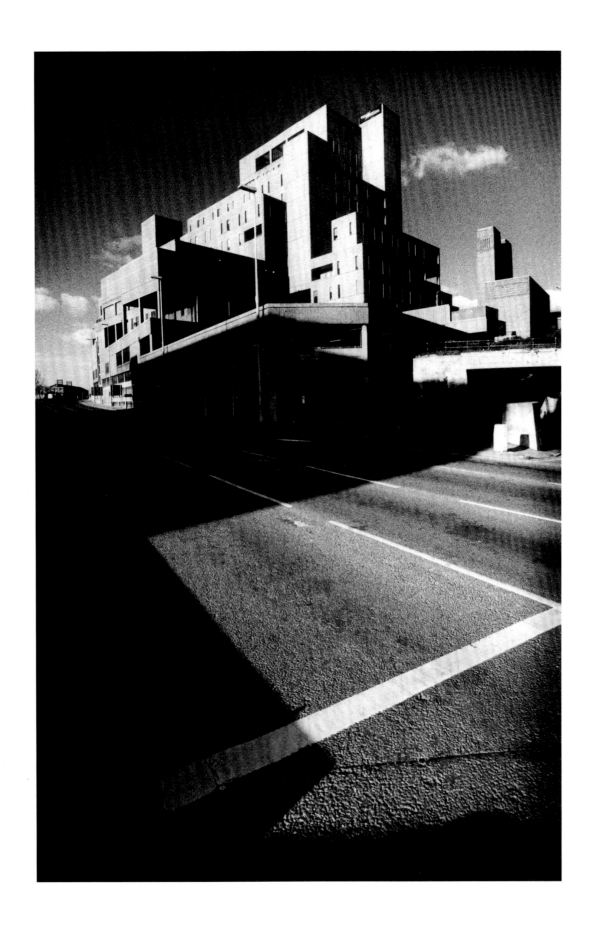

Royal SunAlliance building : Winter 2004

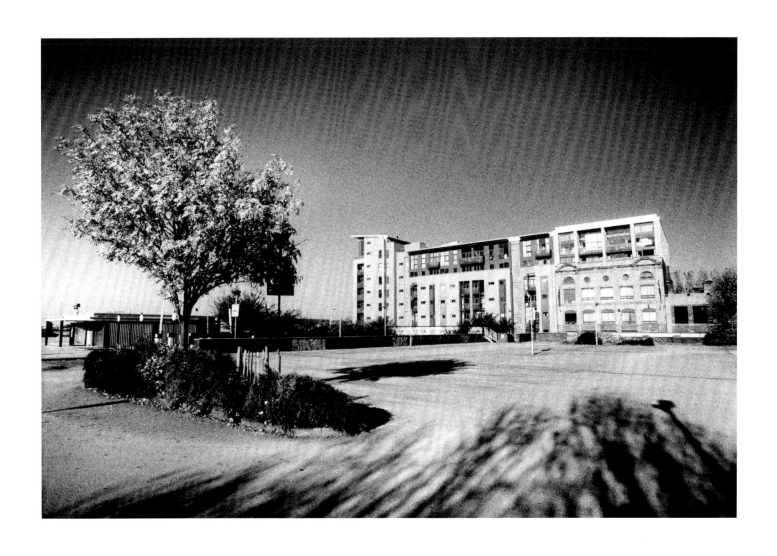

Apartment block, Pall Mall : Winter 2003

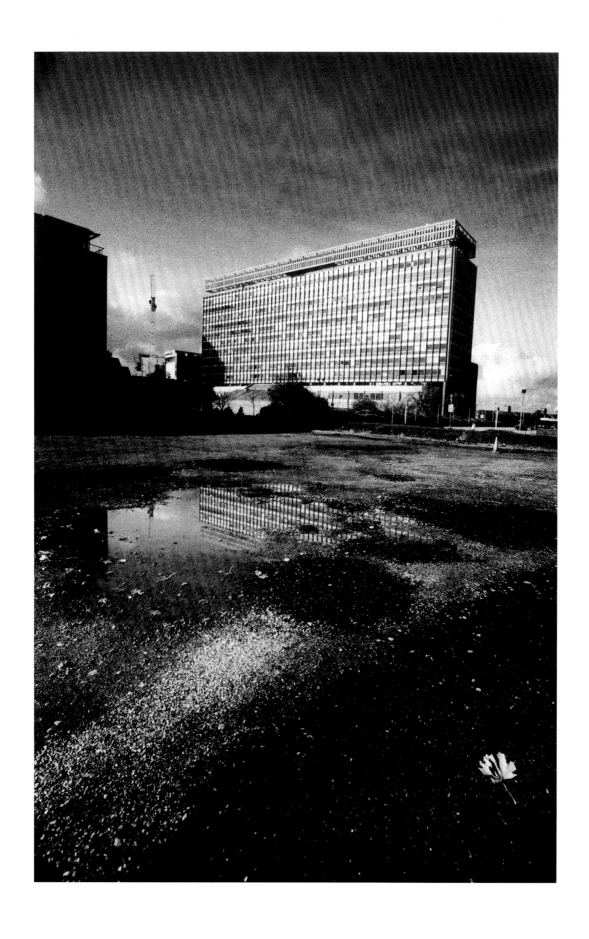

Littlewoods building from Pall Mall : Autumn 2003

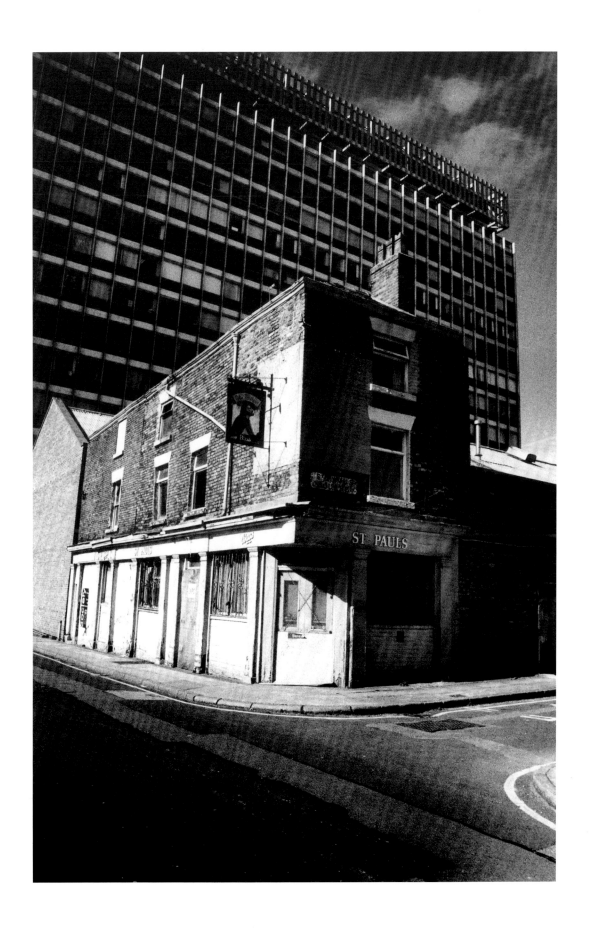

Derelict pub in shadow of Littlewoods building : Spring 2001

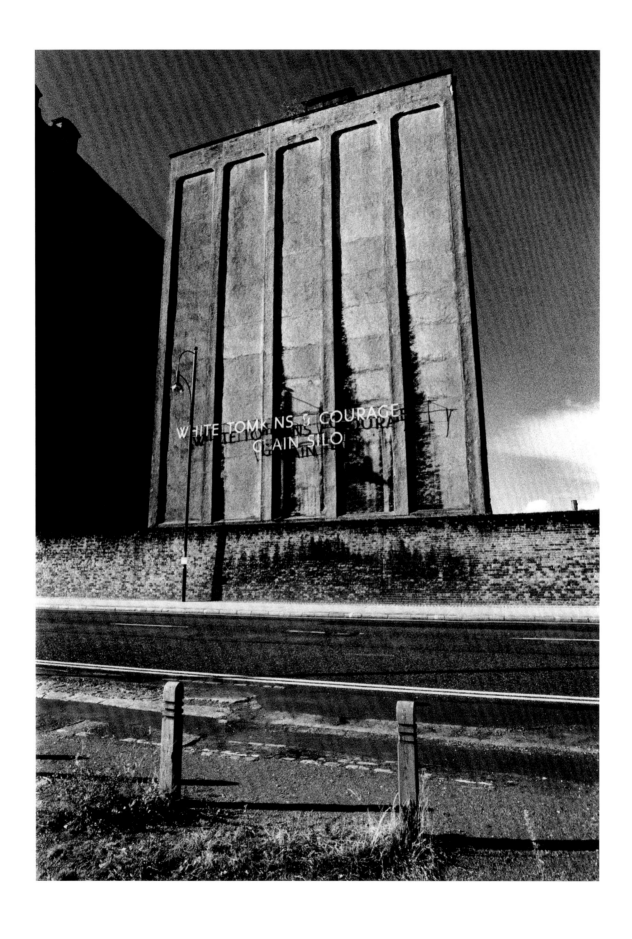

Grain Silo, Great Howard Street : Autumn 2002

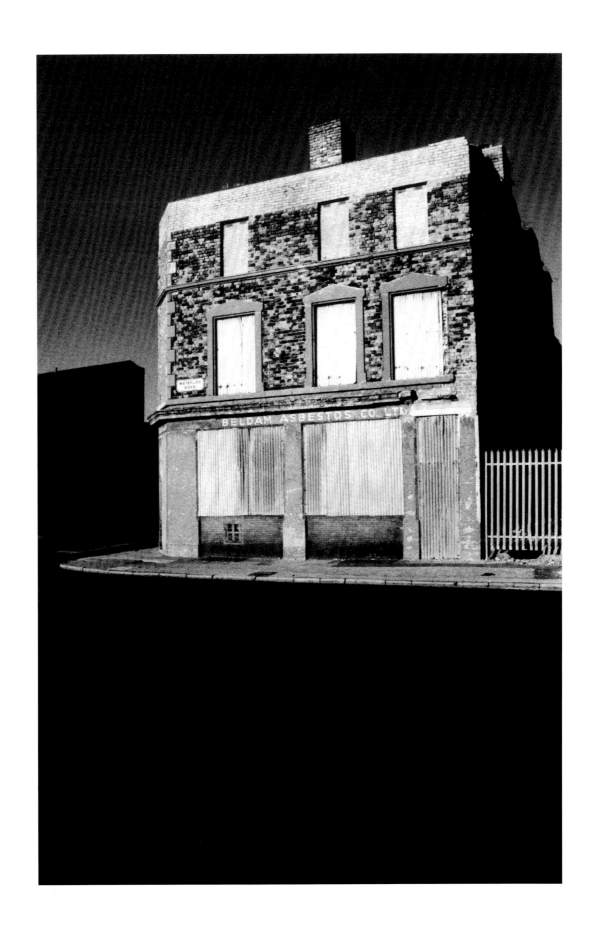

Beldam Asbestos building, Dock Road : 2001

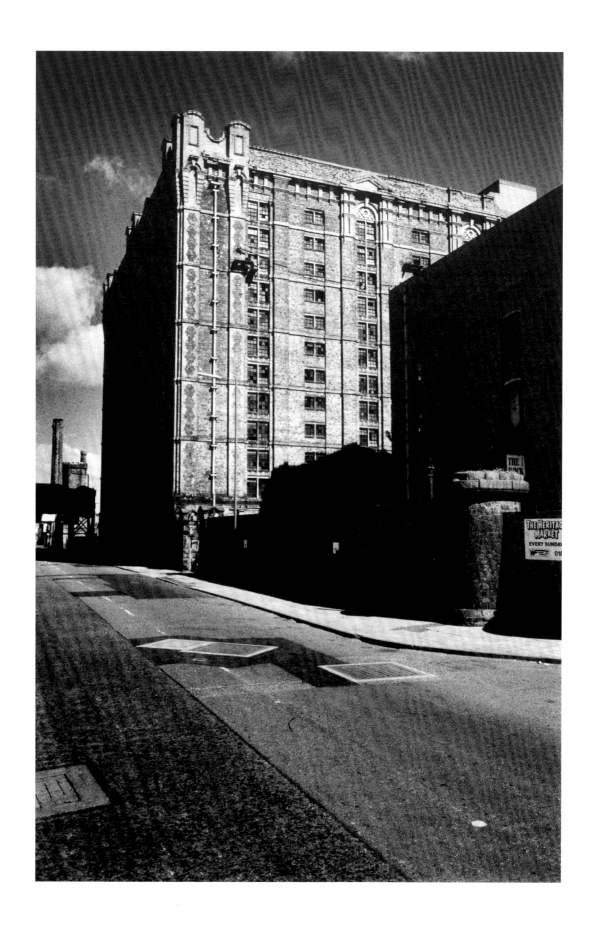

Tobacco Warehouse, Dock Road [Regent Road] : Spring 2002

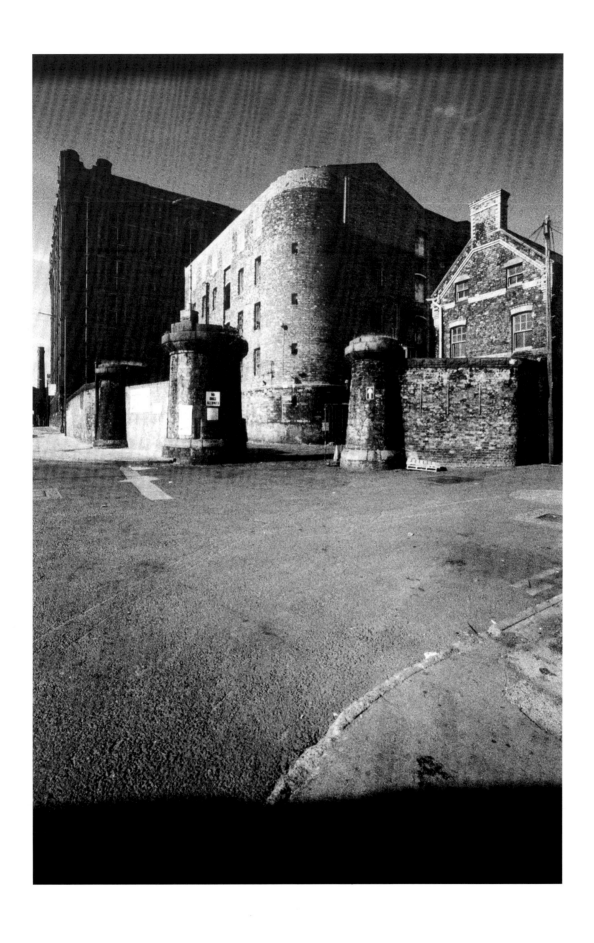

Stanley Dock Conservation area, Dock Road [Regent Road] : Summer 2003

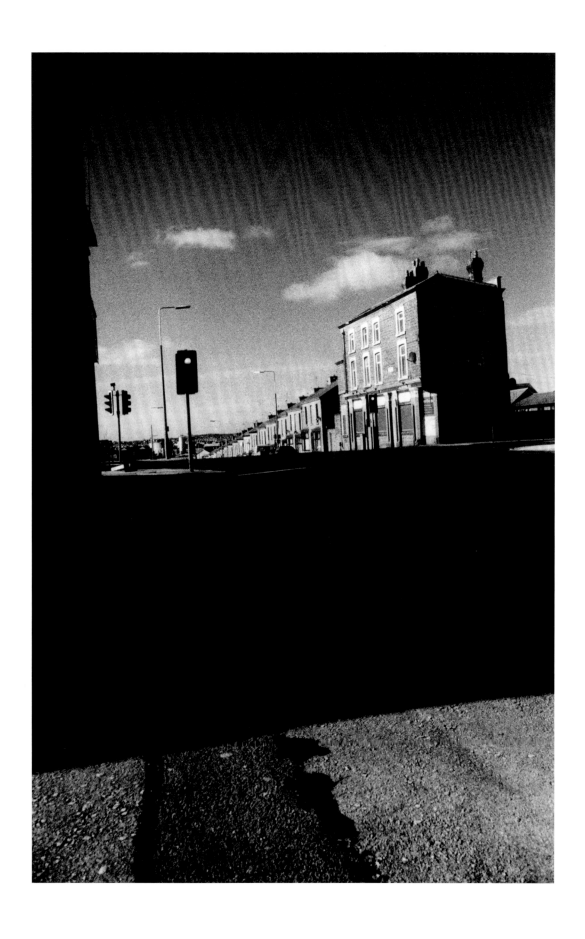

The Lighthouse Public House, Stanley Road : Winter 2005

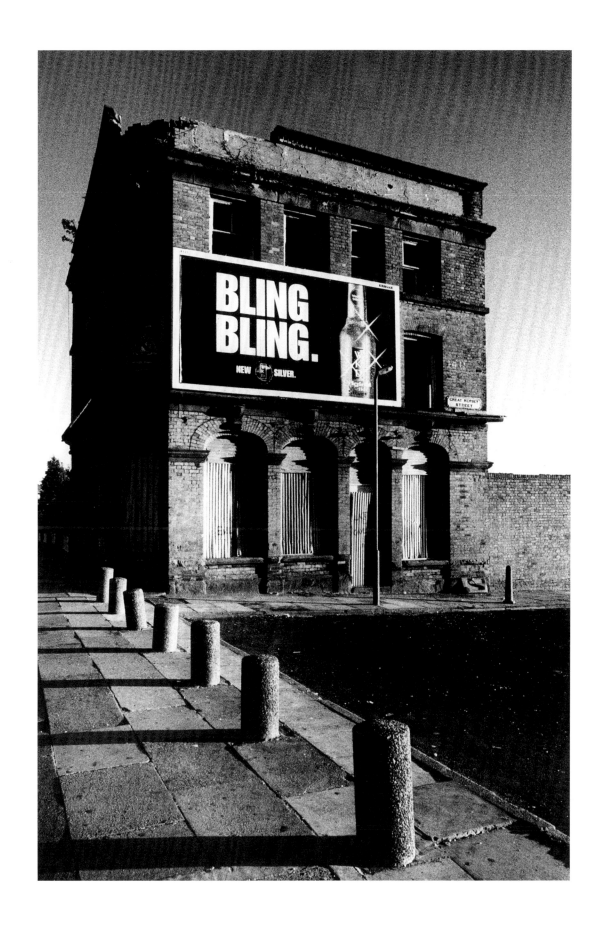

Derelict Public House, Stanley Road : Summer 2004

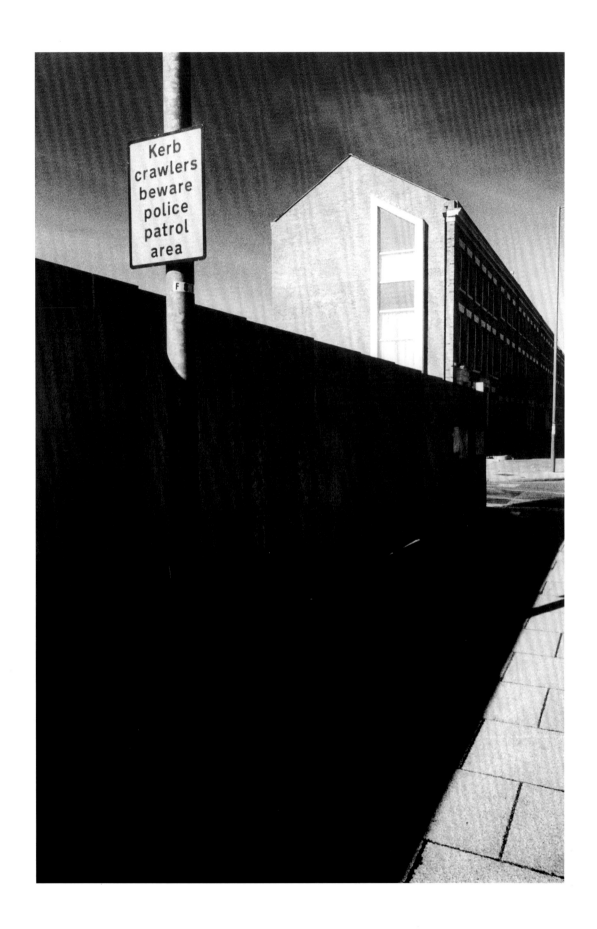

Moss Street, refurbished terraced housing : Spring 2005

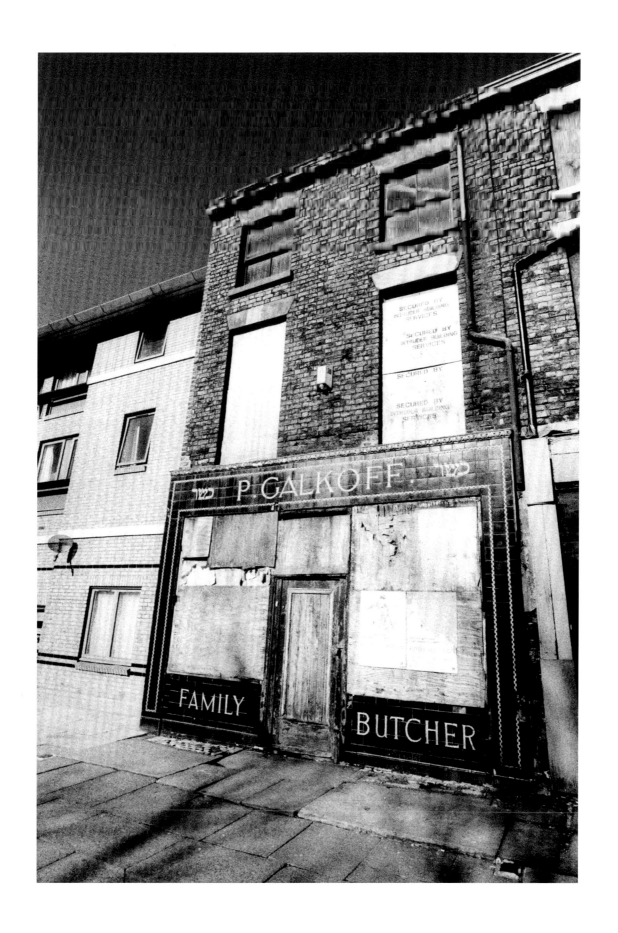

Galkoff Butchers, London Road : Winter 2003

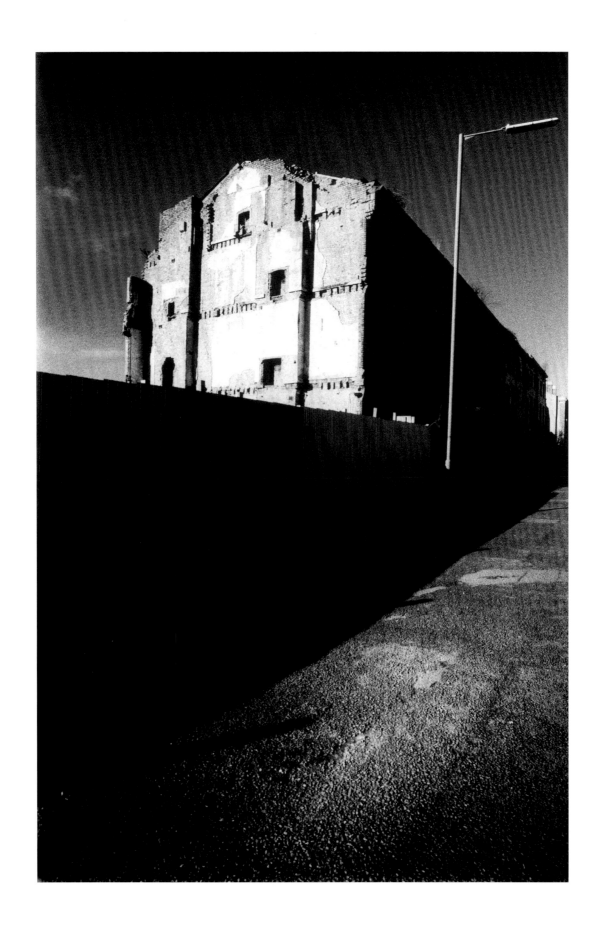

Derelict terracing, Moss Street : Winter 2003

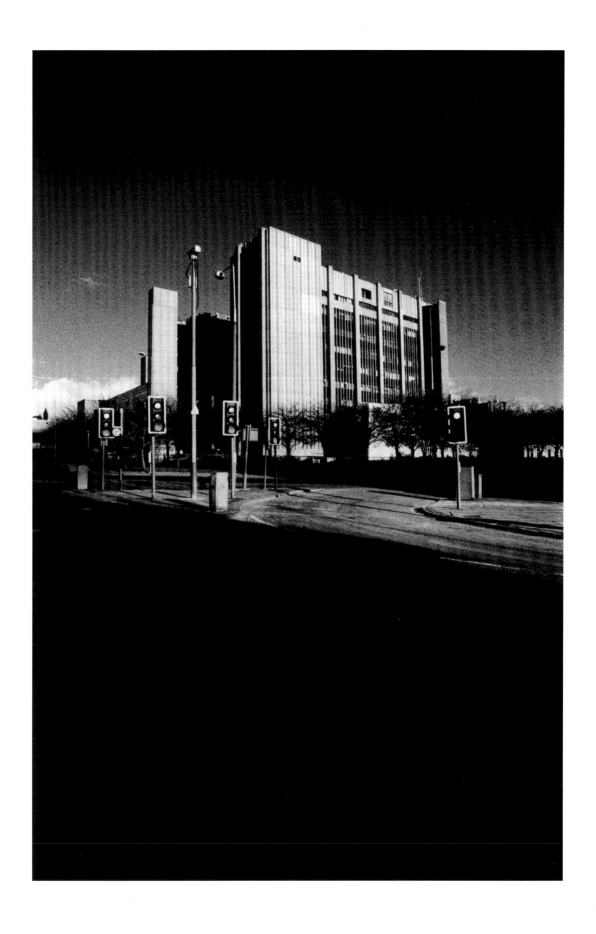

Royal Liverpool Hospital : April 2004

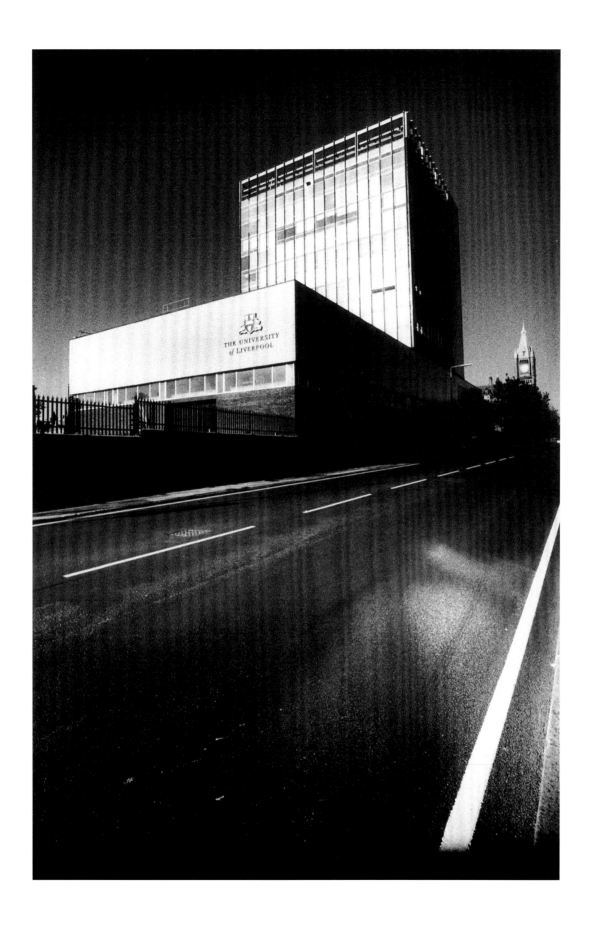

University of Liverpool, Engineering Building, Brownlow Hill : Summer 2003

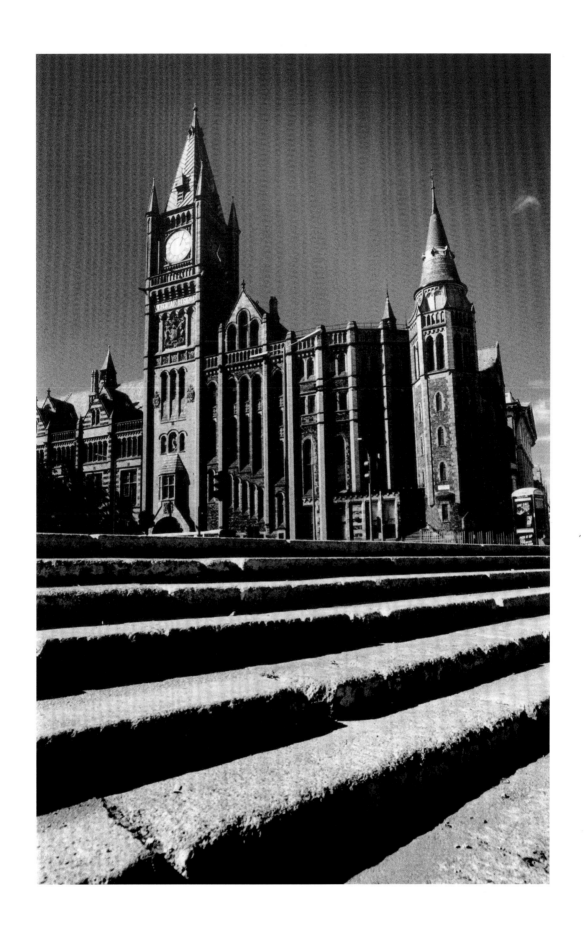

Victoria Building, University of Liverpool, Brownlow Hill : Autumn 2004

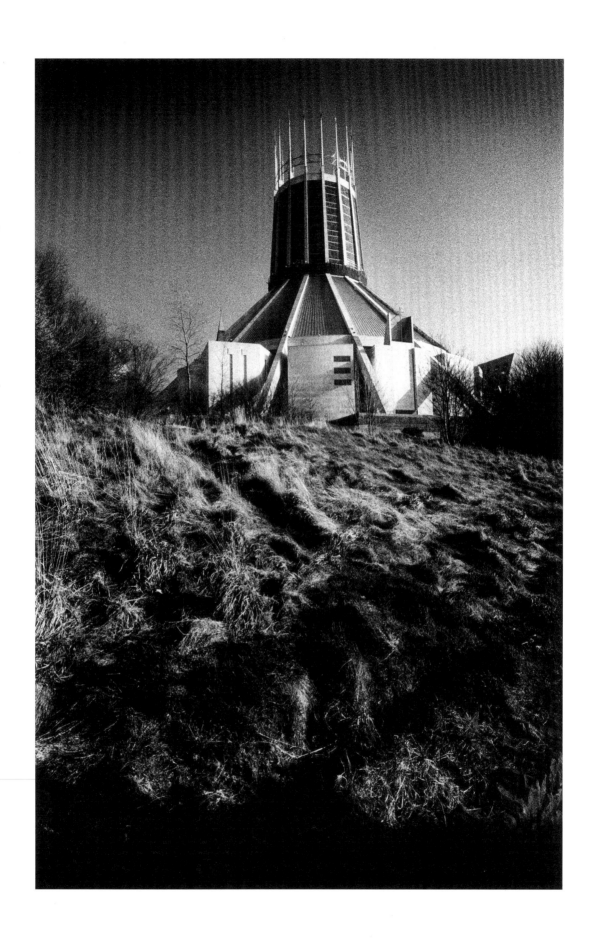

Metropolitan Cathedral of Christ the King, Brownlow Hill : Winter 2003

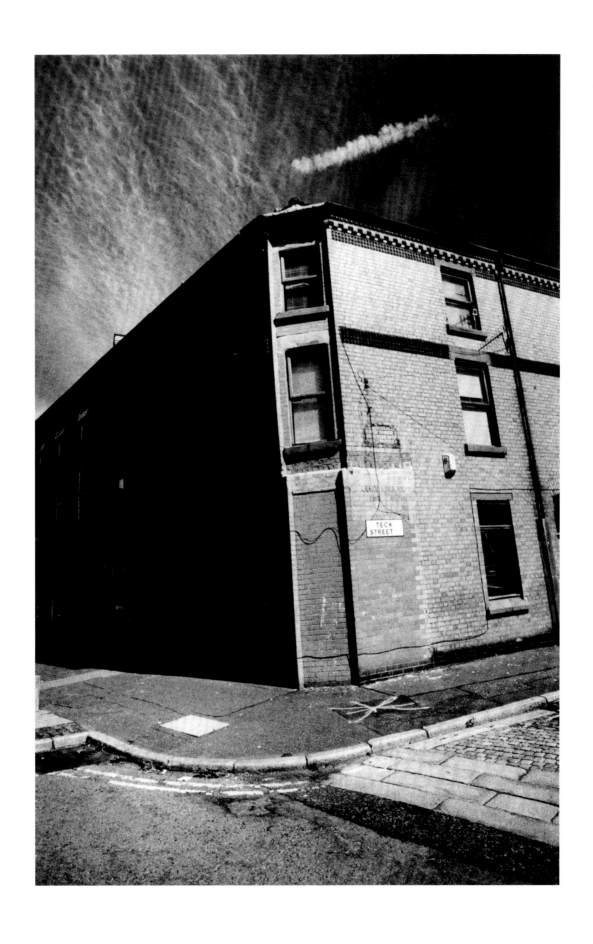

Teck Street, Kensington : Summer 2004

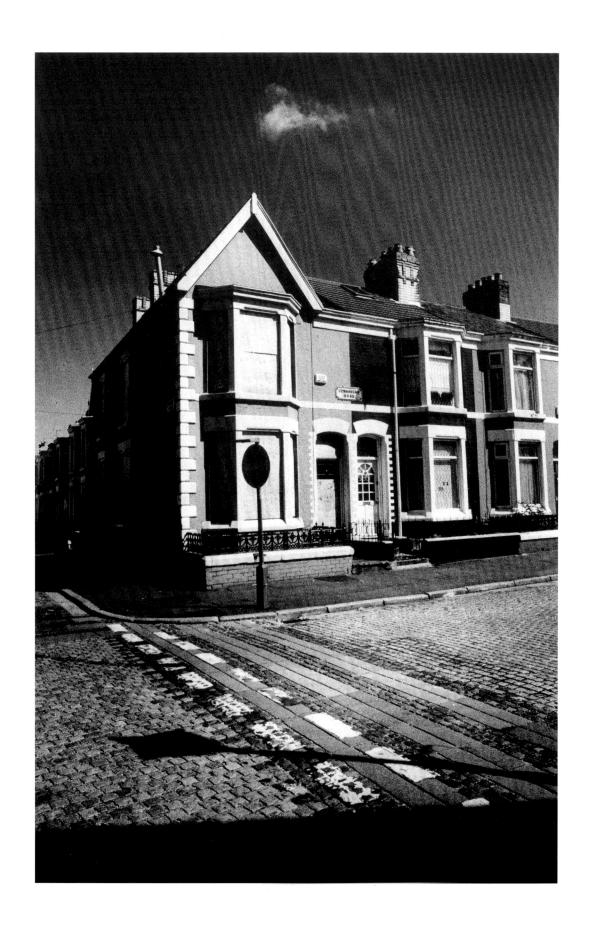

Connaught Road, Kensington : Summer 2004

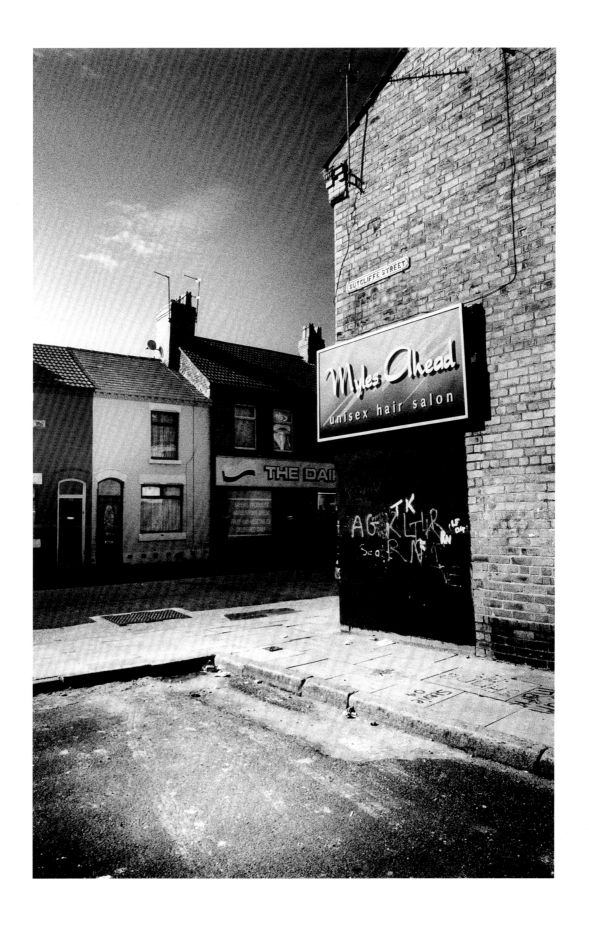

Sutcliffe Street corner : Summer 2004 :

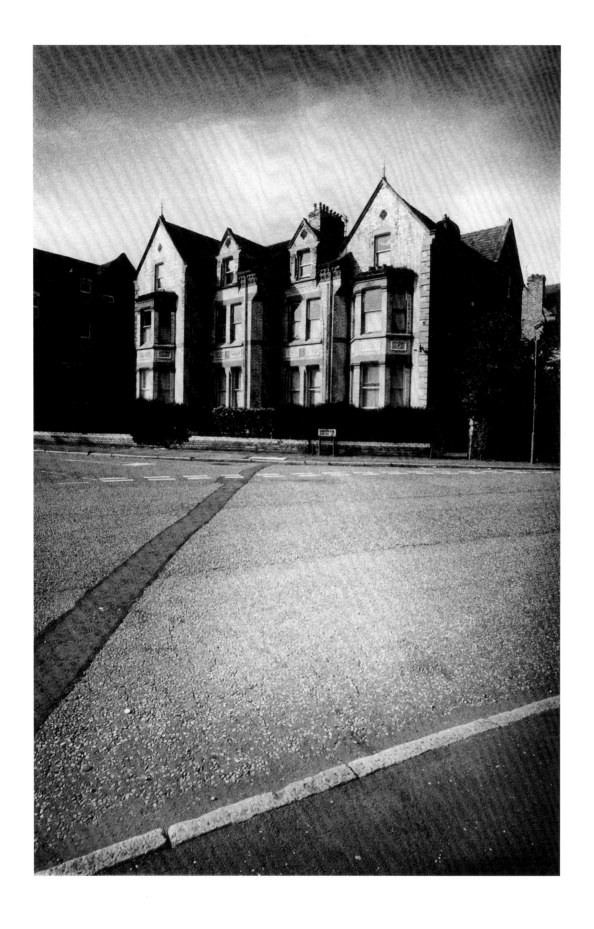

Denman Drive : Autumn 2005

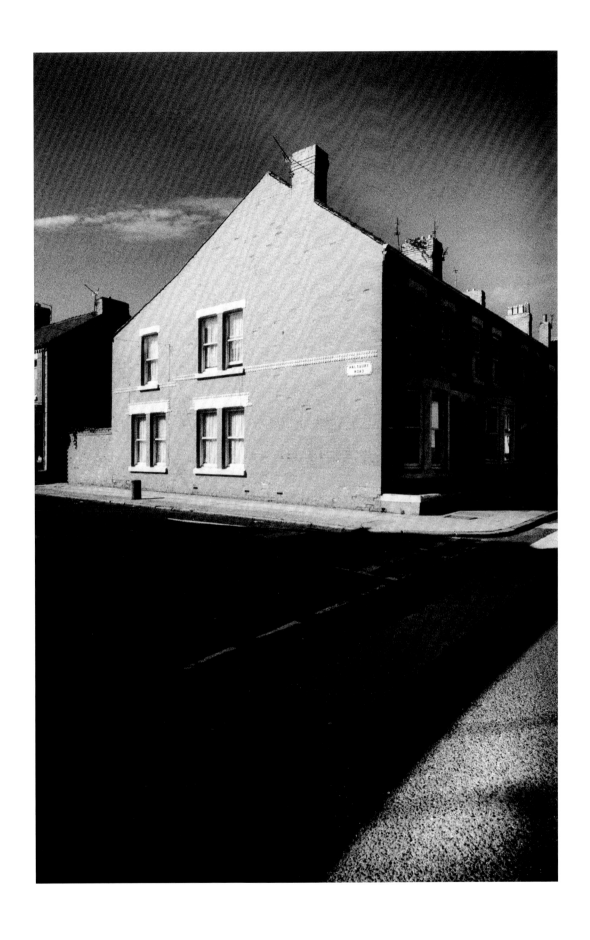

Halsbury Road : Summer 2004

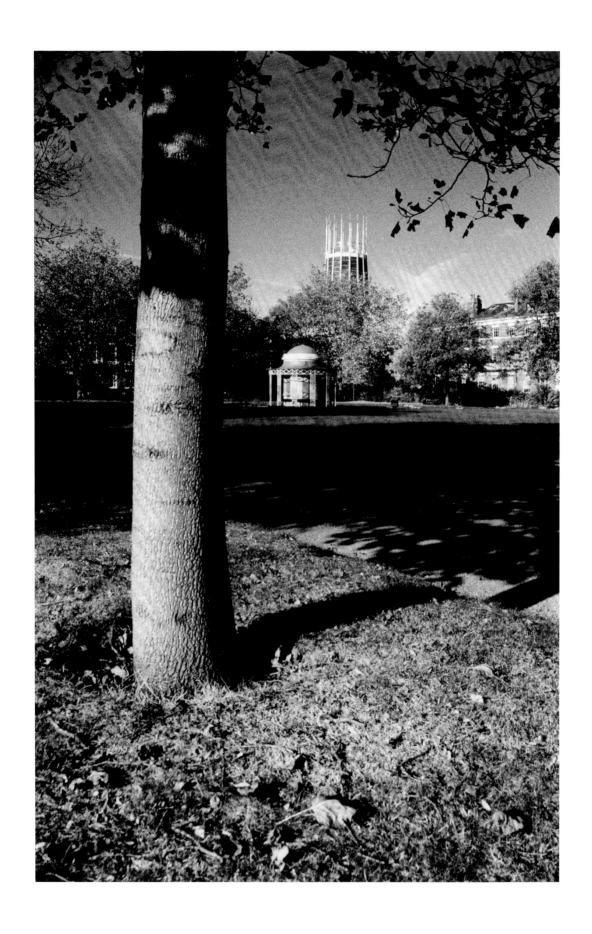

Abercromby Square : Autumn 2003

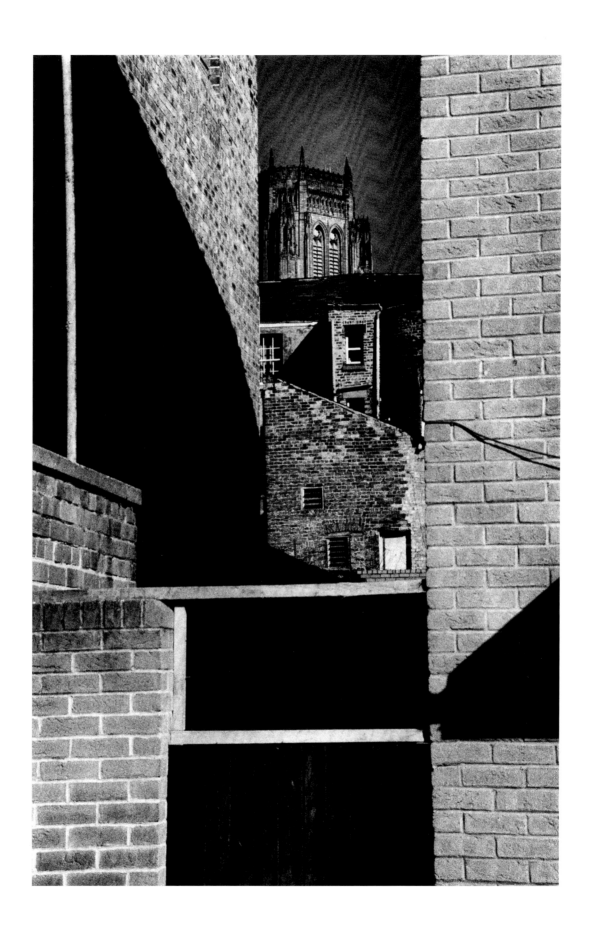

Vestey Tower, Anglican Cathedral : Summer 2003

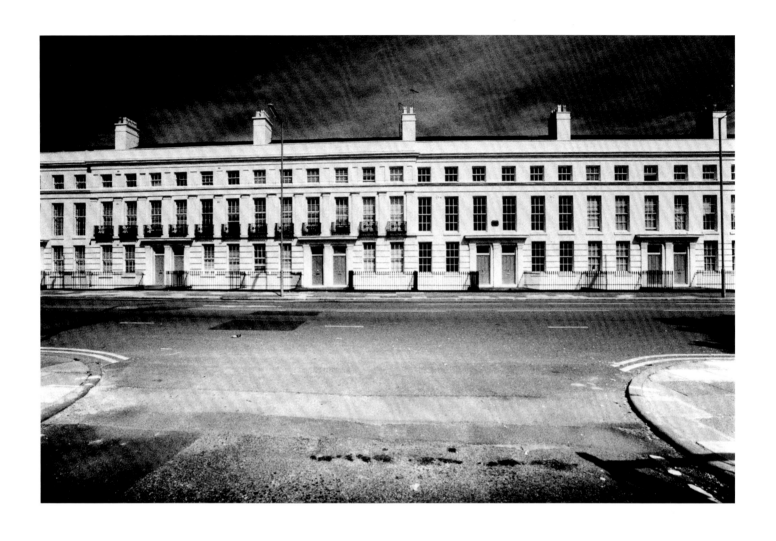

Terraced housing, Upper Parliament Street : Summer 2004

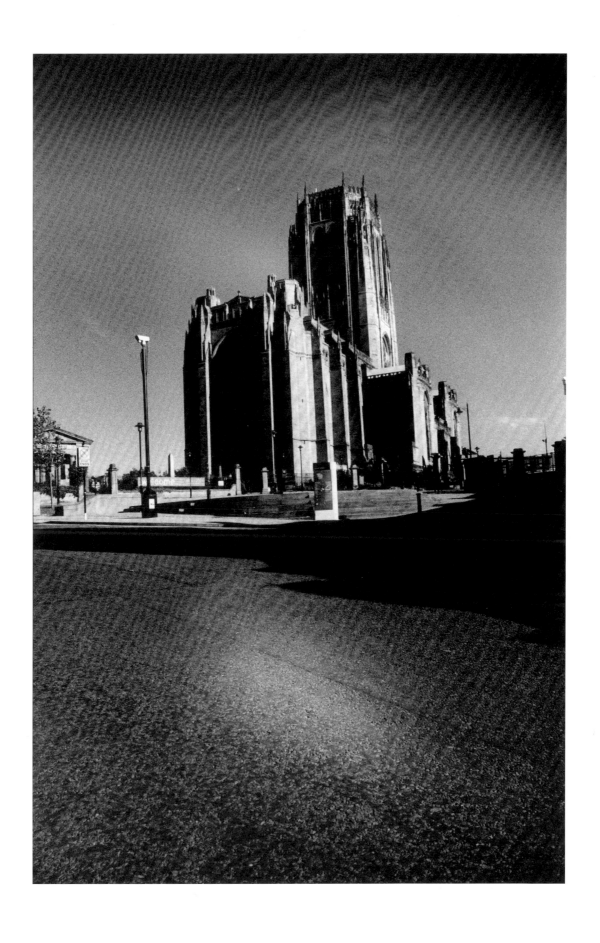

Anglican Cathedral : Summer 2003

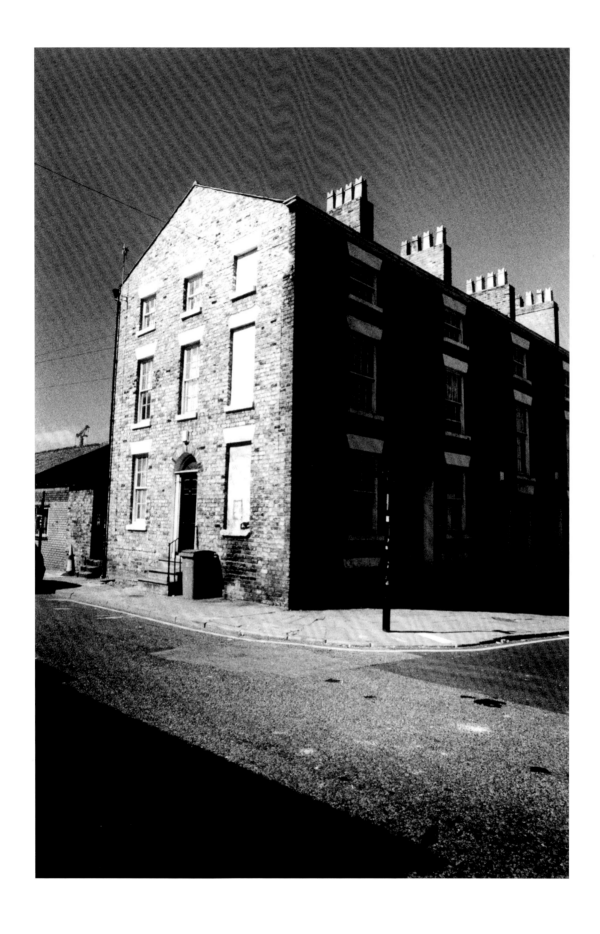

Mount Street : Summer 2005

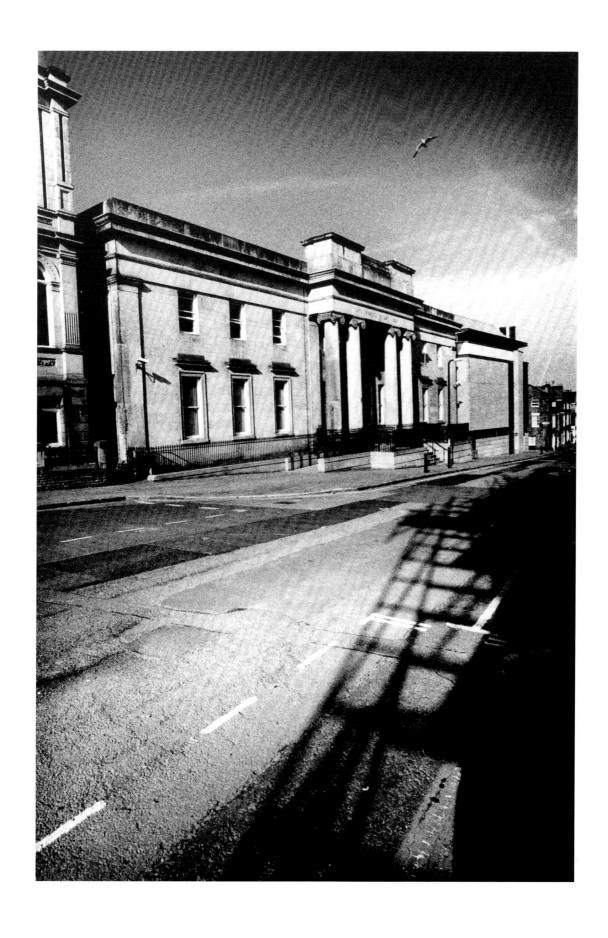

LIPA Mount Street : Summer 2005

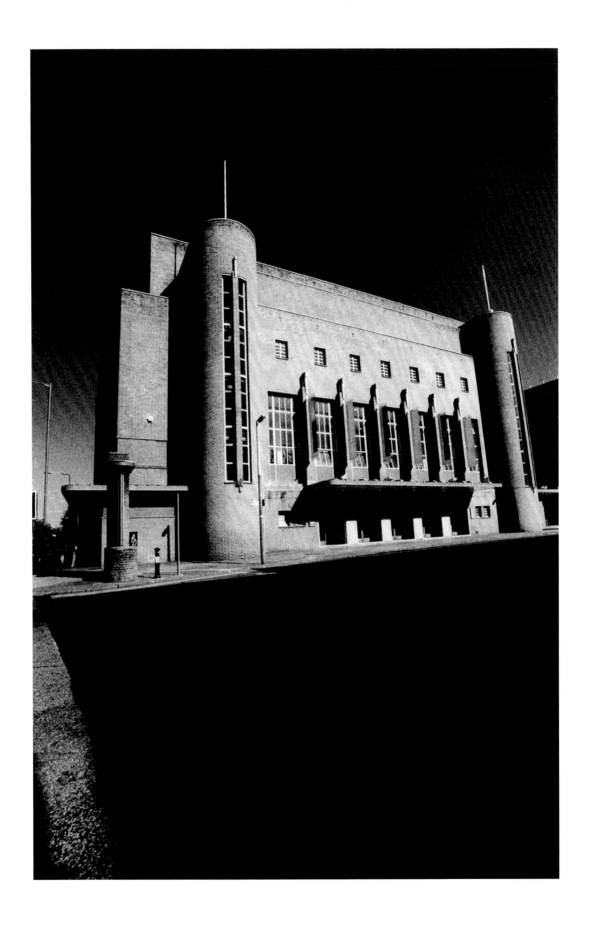

Philharmonic Hall : Summer 2004

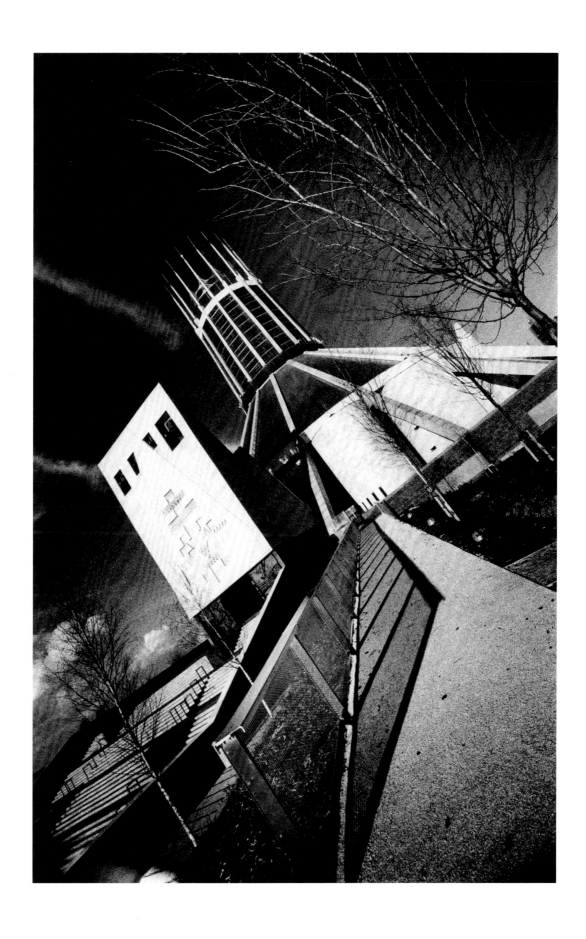

Metropolitan Cathedral of Christ the King, Mount Pleasant : Autumn 2003

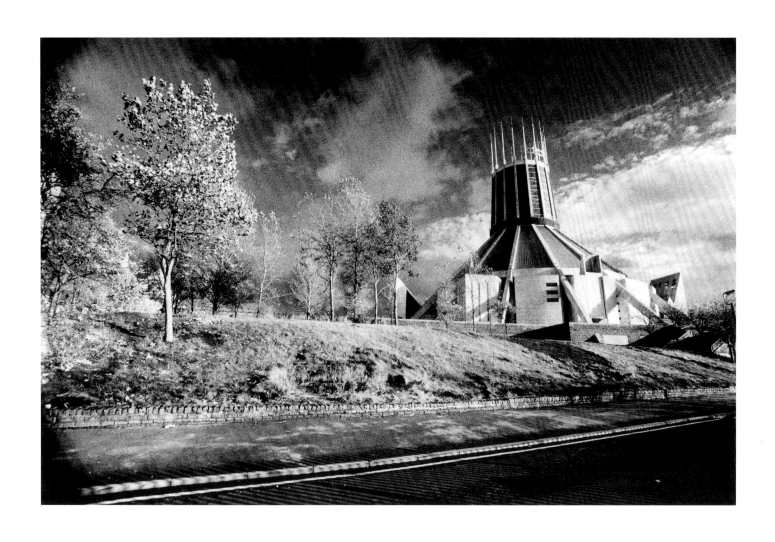

Metropolitan Cathedral of Christ the King, Duckinfield Street : Winter 2003

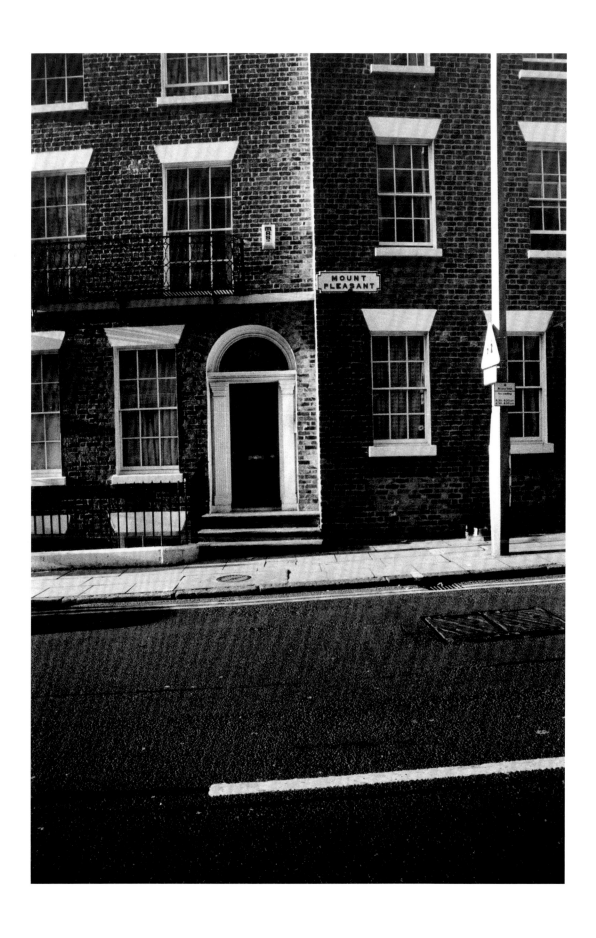

Mount Pleasant : Spring 2001

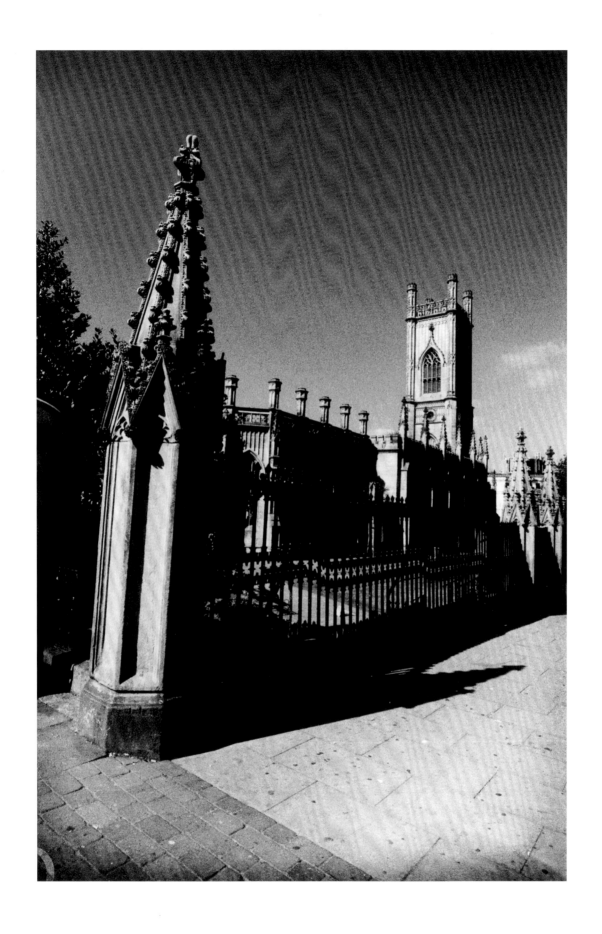

Ruins of St Luke's Church, Leece Street : Summer 2005

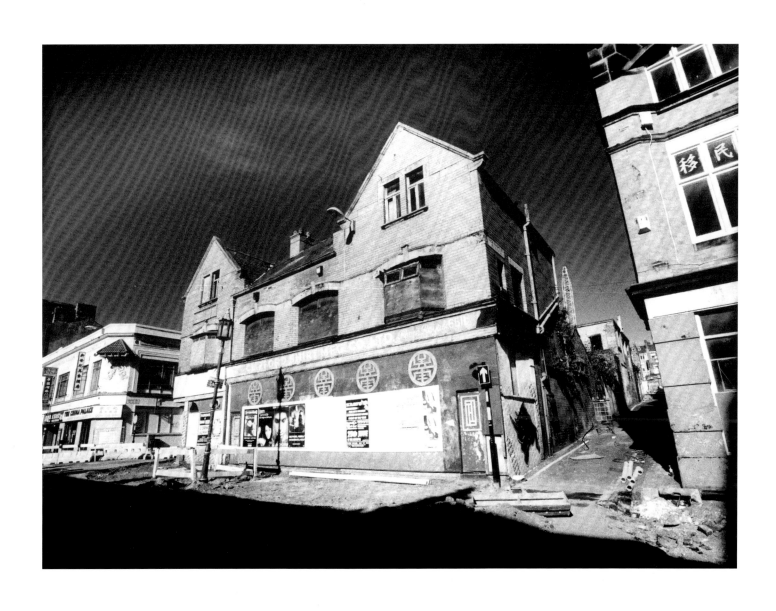

Roadworks, Berry Street [part of the Big Dig] : Summer 2005

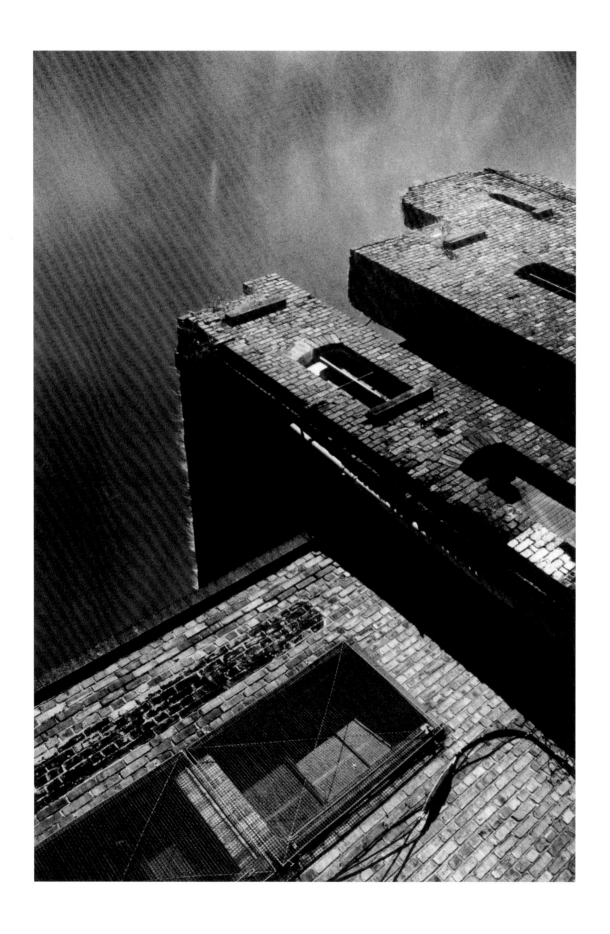

Henry Street, Ropewalks conservation area : Winter 2001

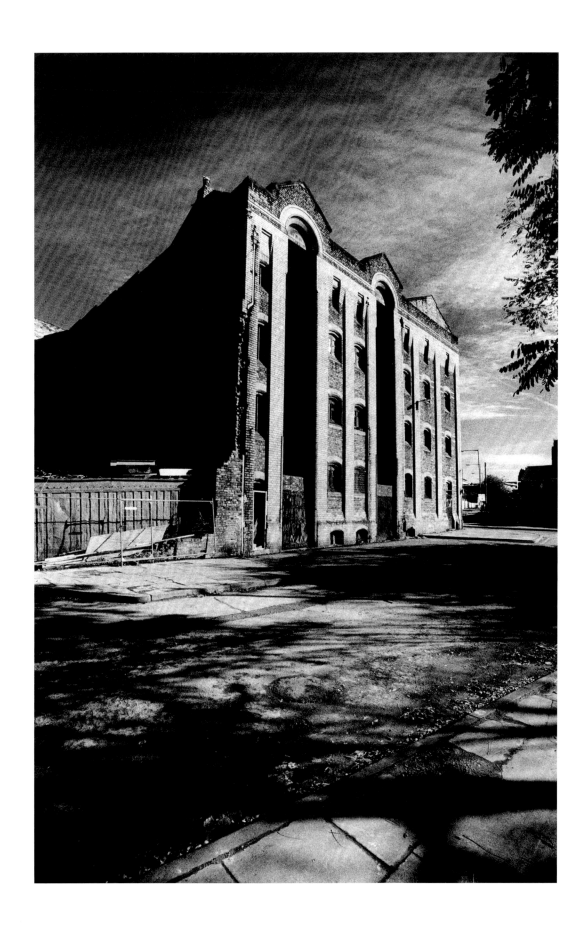

Warehousing conversion into private residential apartments, Ropewalks conservation area : Autumn 2003

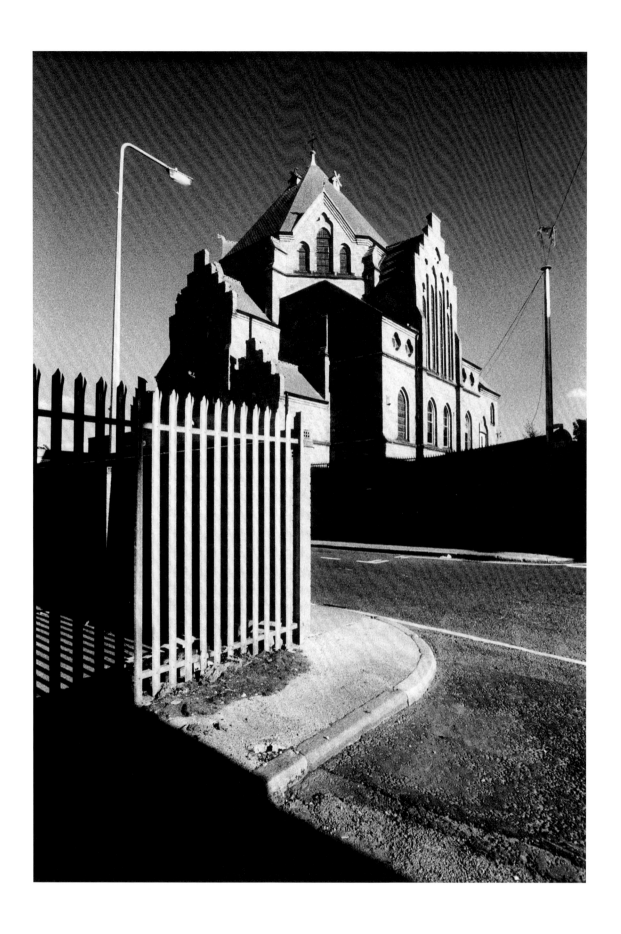

Swedish Church, Park Lane : 2002

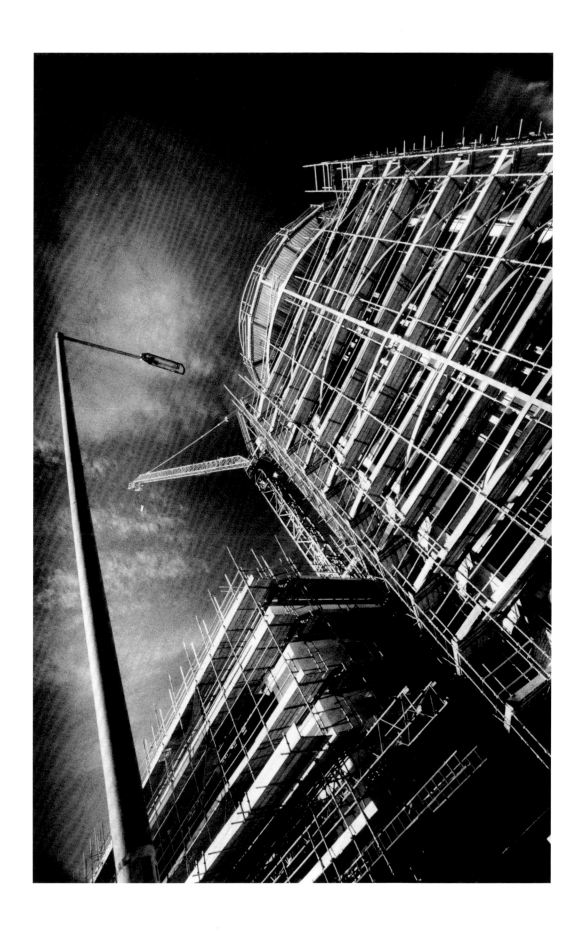

New apartments, Lydia Ann Street, Ropewalks conservation area : Spring 2005

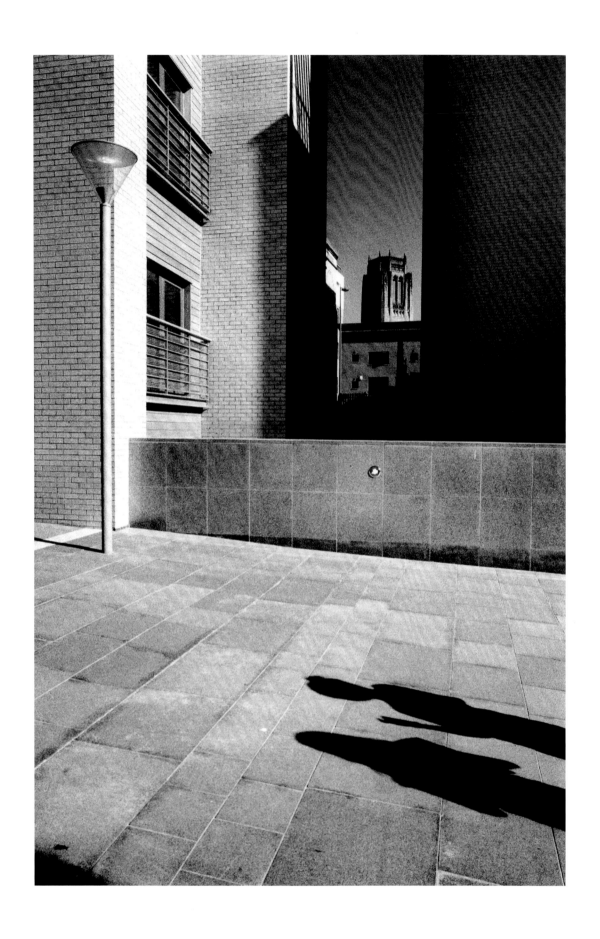

Vestey Tower, Anglican Cathedral from East Village, Ropewalks conservation area : 2004

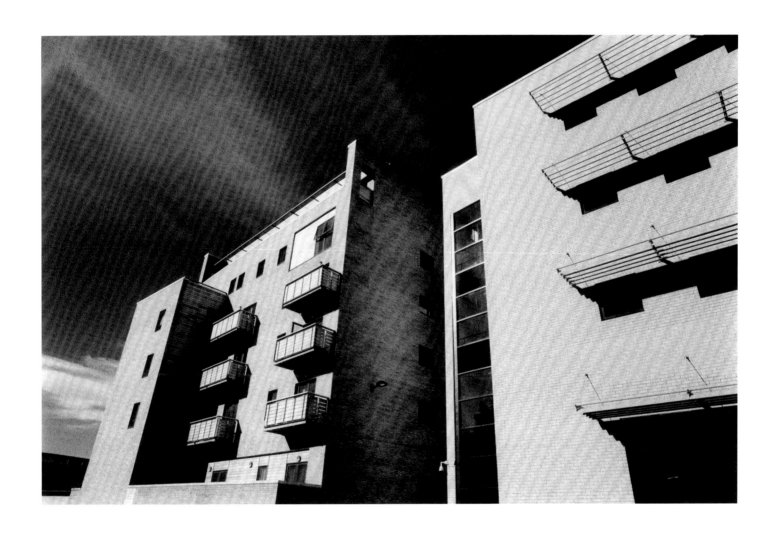

Apartments, Lydia Ann Street : Summer 2004

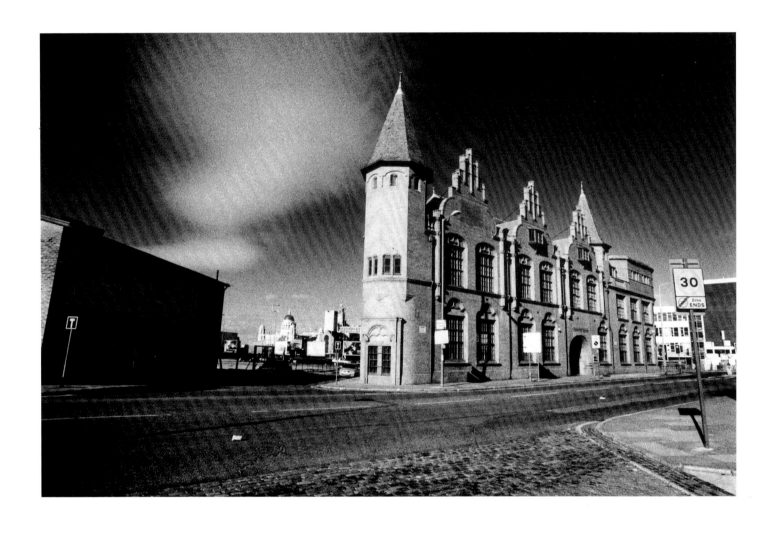

Back of Canning Place : Winter 2004

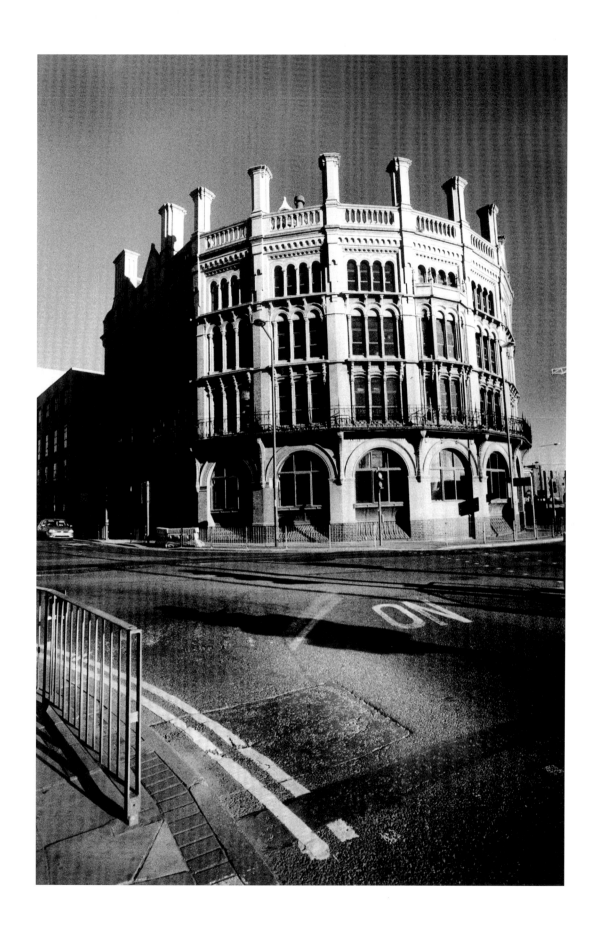

Junction of Paradise Street & Hanover Street : Summer 2005

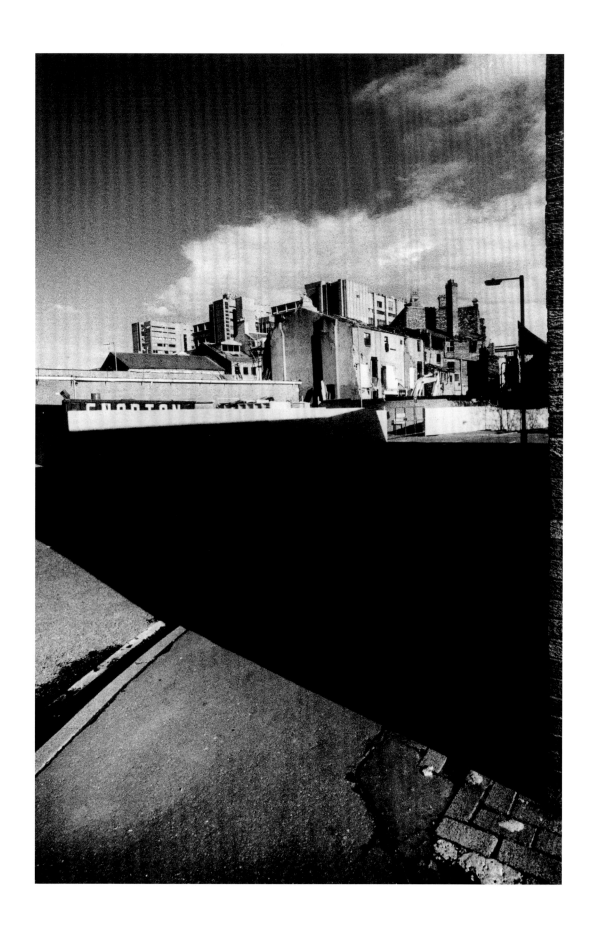

Distant view of Royal Liverpool Hospital : Spring 2004

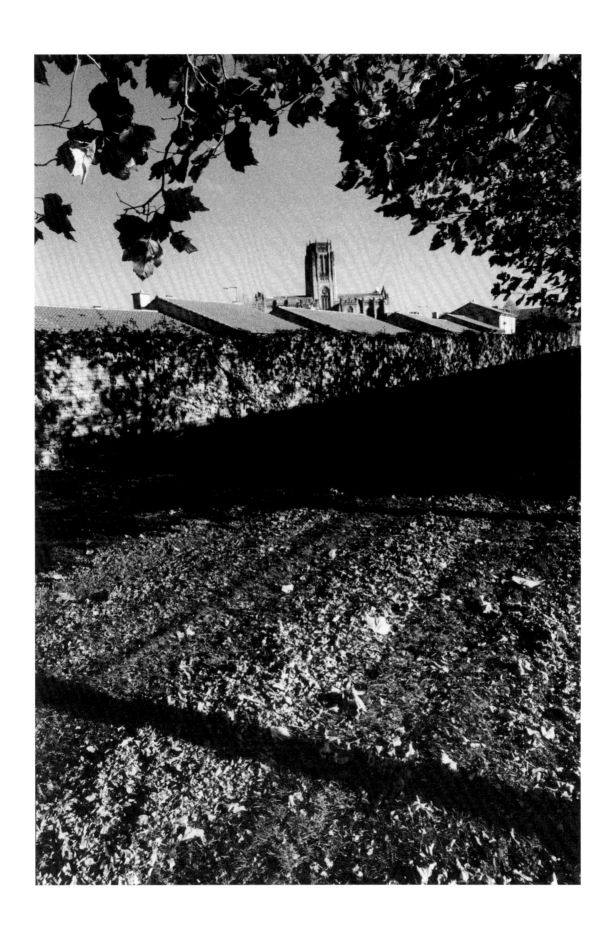

Anglican Cathedral from Park Lane : Autumn 2001

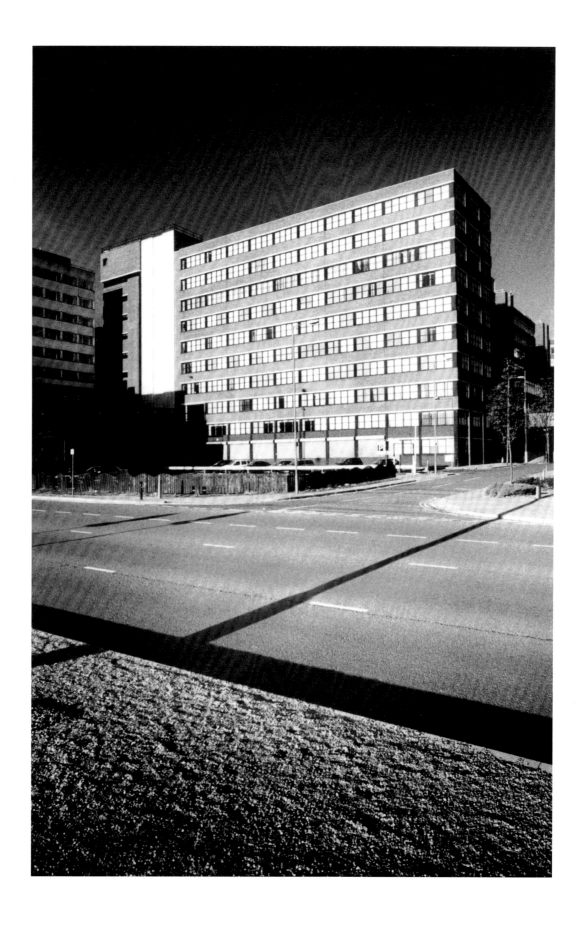

Strand Street : Autumn 2003

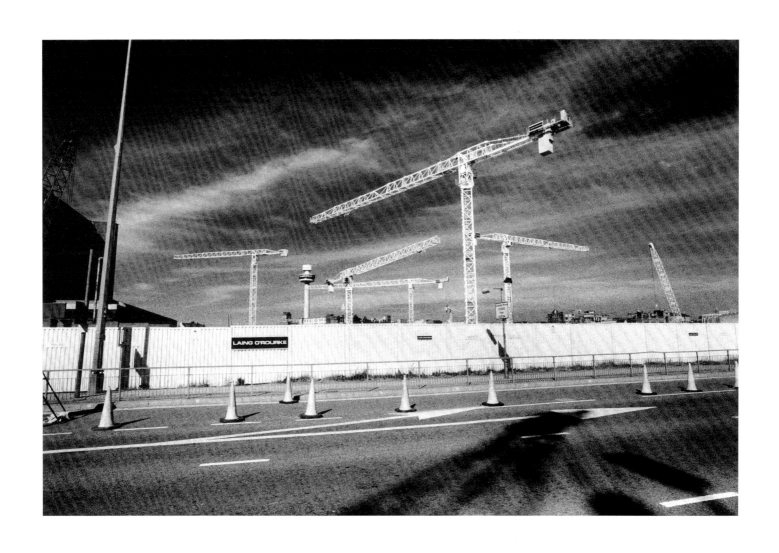

Paradise Project, retail and residential development, near Chavasse Park : Summer 2004

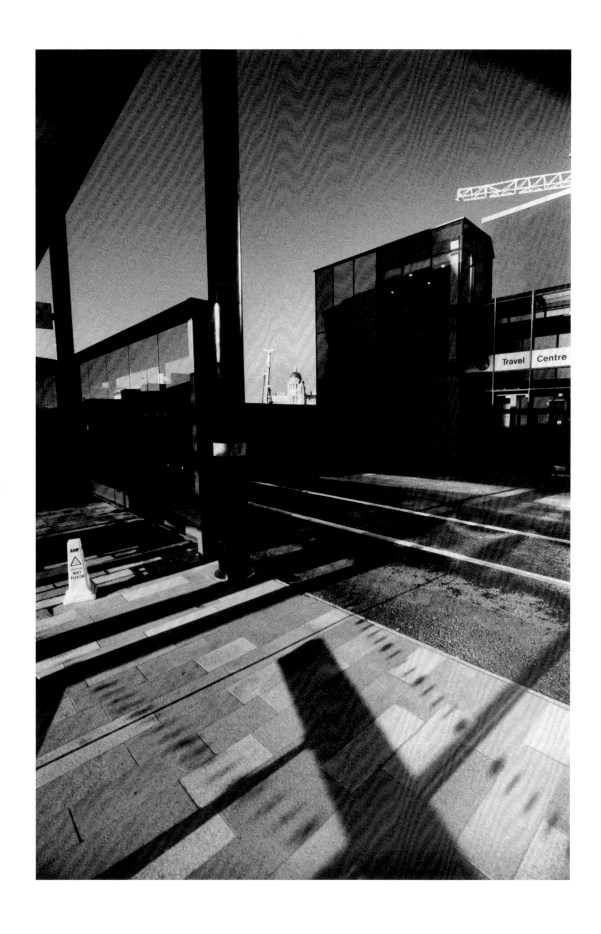

Paradise Interchange bus station, Liver Street : Winter 2005

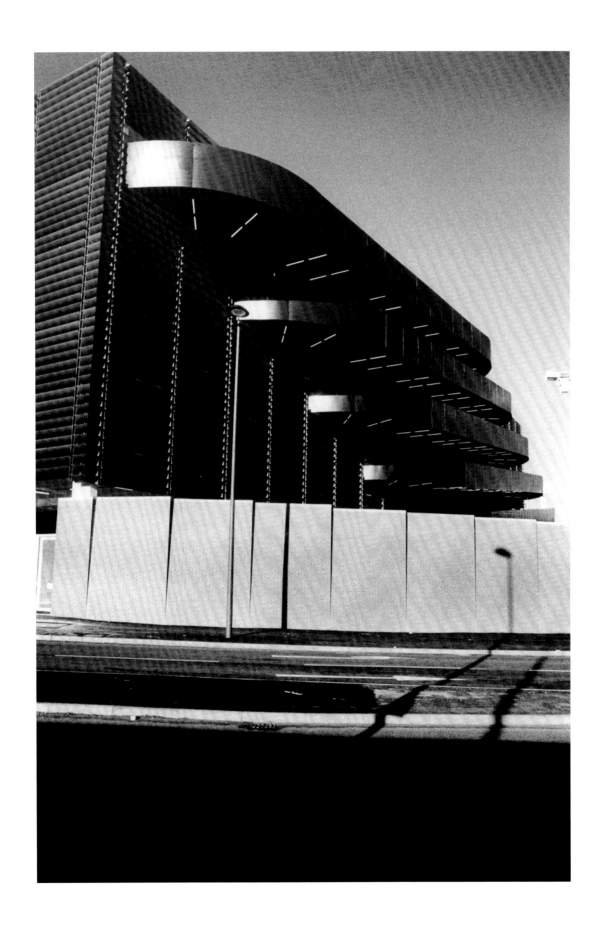

Car Park, Liver Street : Autumn 2005

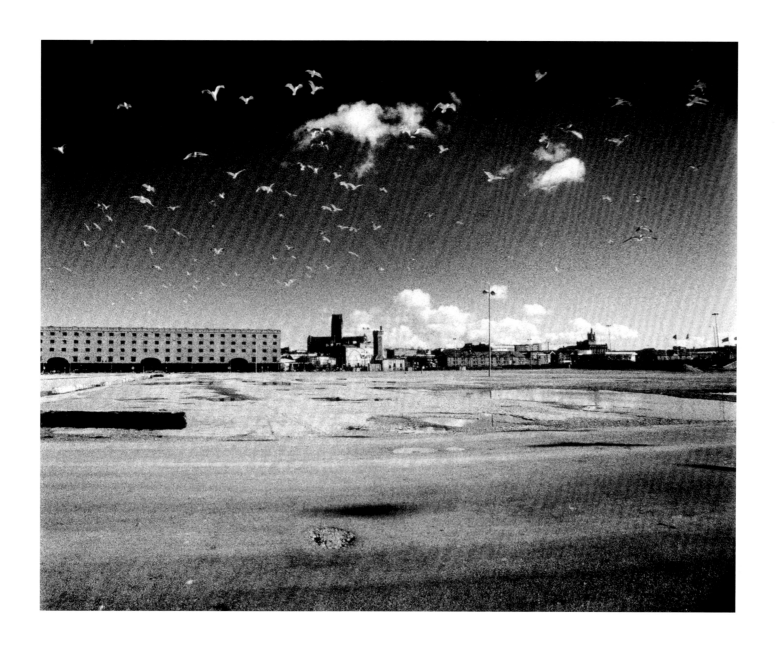

Kings Dock awaiting re-development : Spring 2003

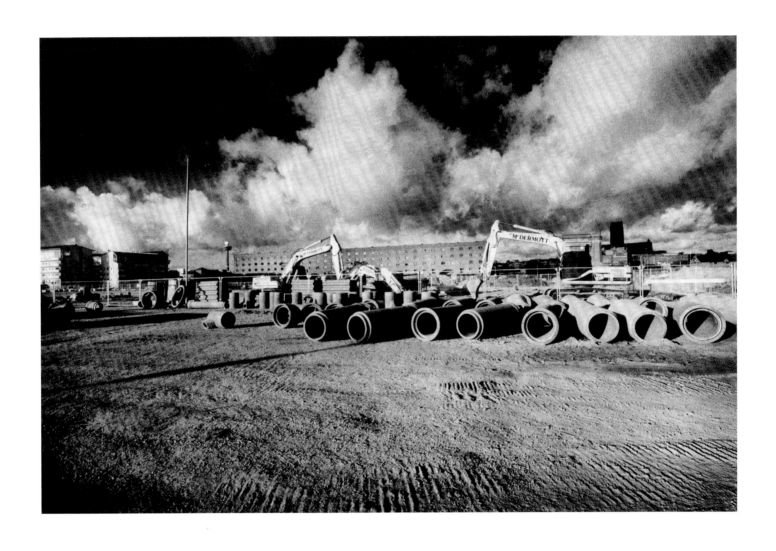

Kings Dock re-development : Summer 2005

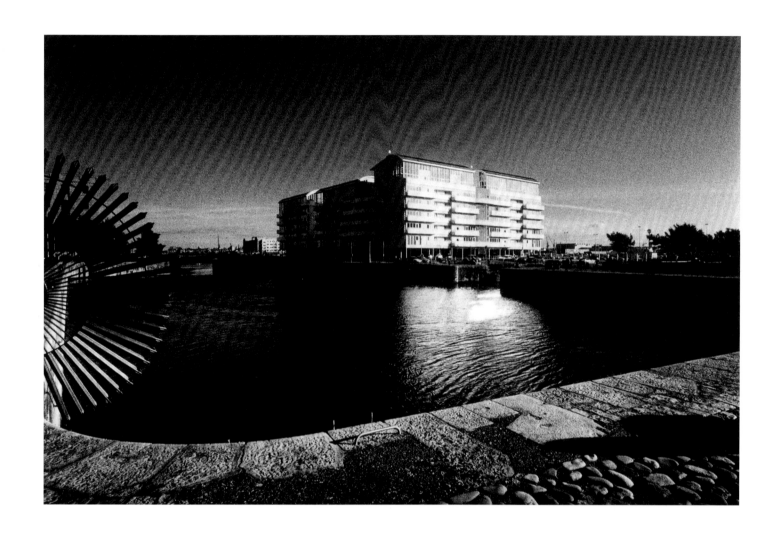

Royal Quay apartments : Summer 2003

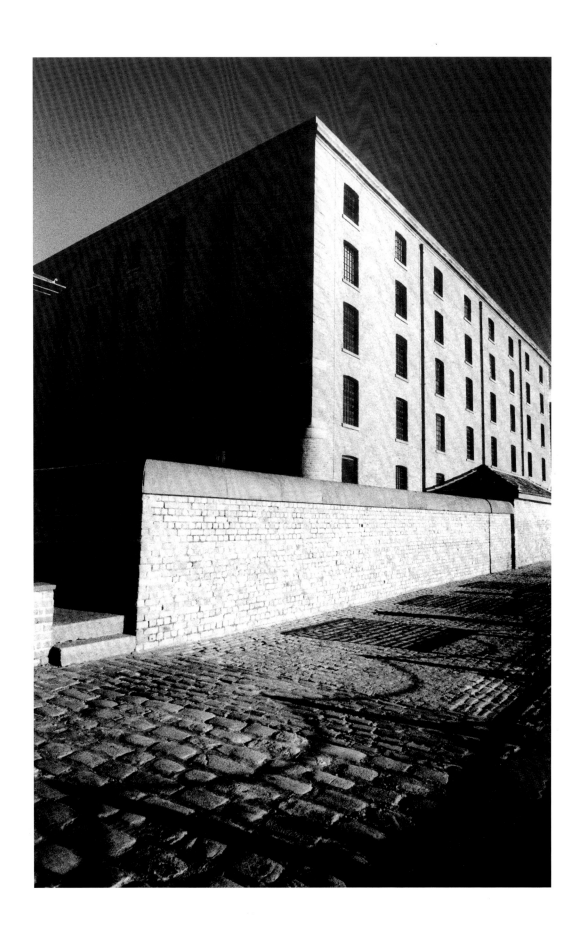

Albert Dock walkway : Winter 2004

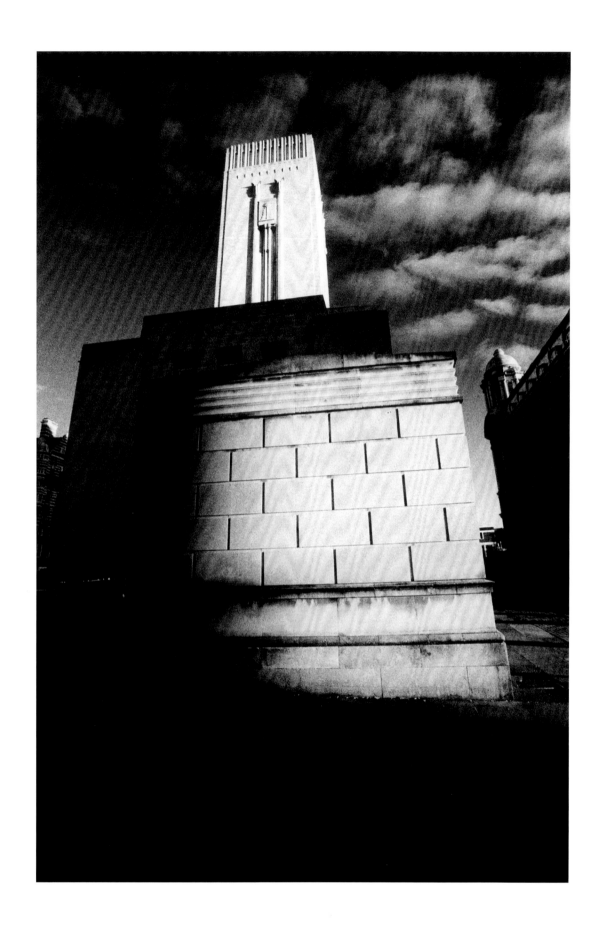

Birkenhead Tunnel Ventilation Shaft : Autumn 2003

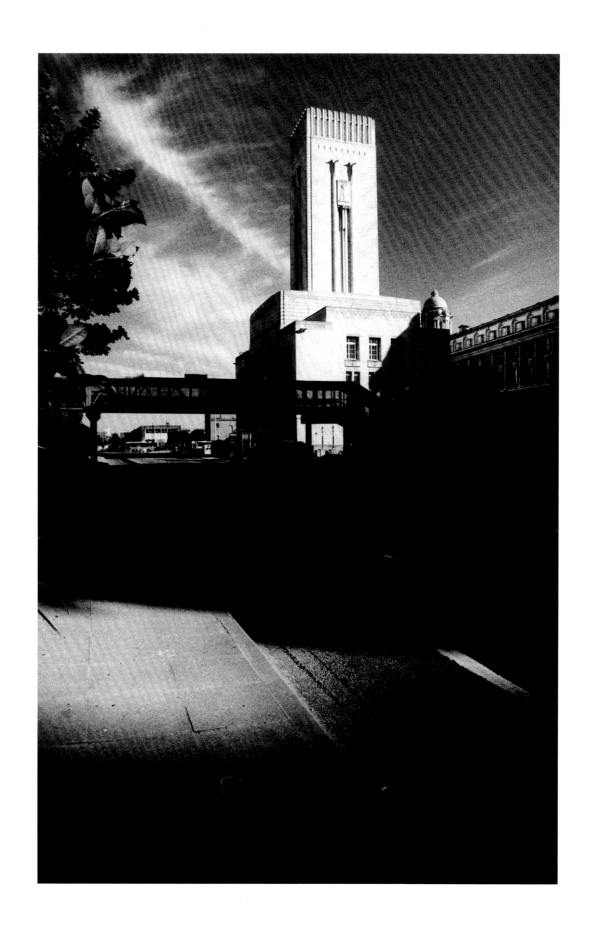

Birkenhead Tunnel Ventilation Shaft from the Strand : Summer 2005

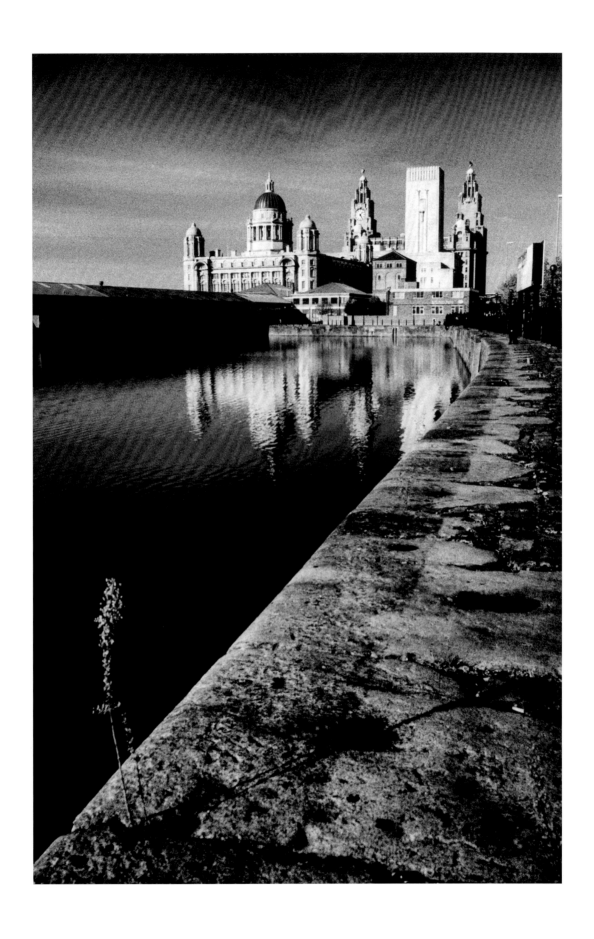

Canning Dock and Liver Building : Autumn 2003

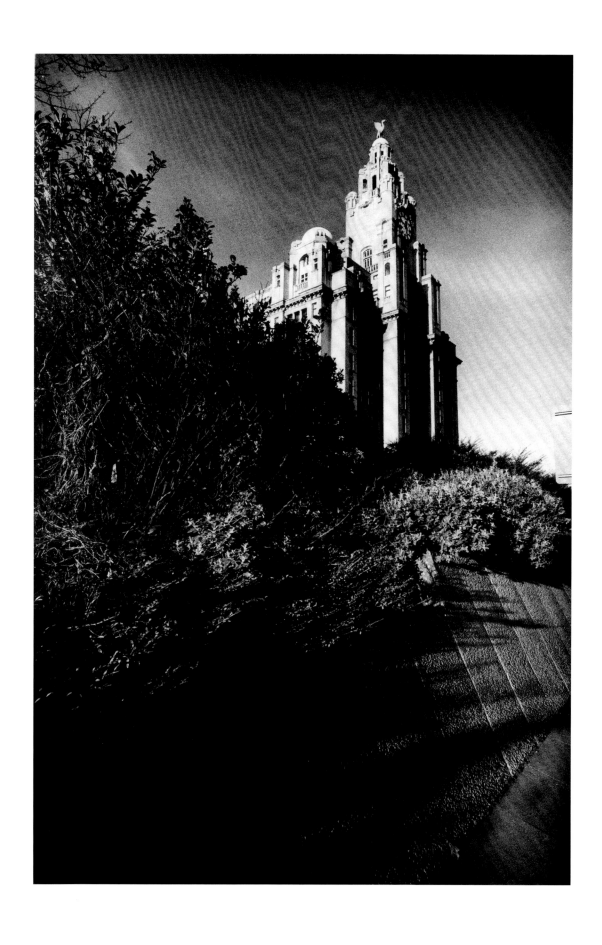

Central reservation, The Strand : Autumn 2005

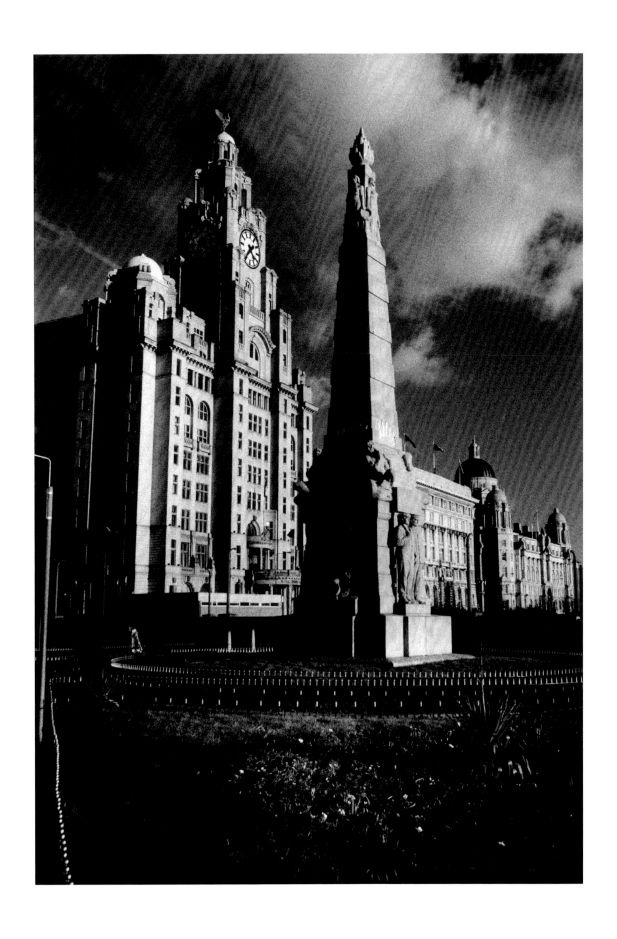

Memorial to the Engine Room Heroes : Winter 2004

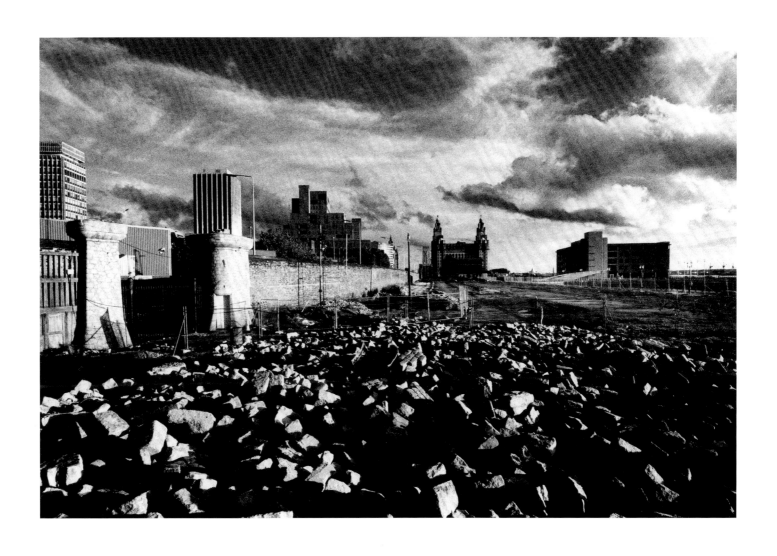

Site of Beetham Towers 2 : Autumn 2001

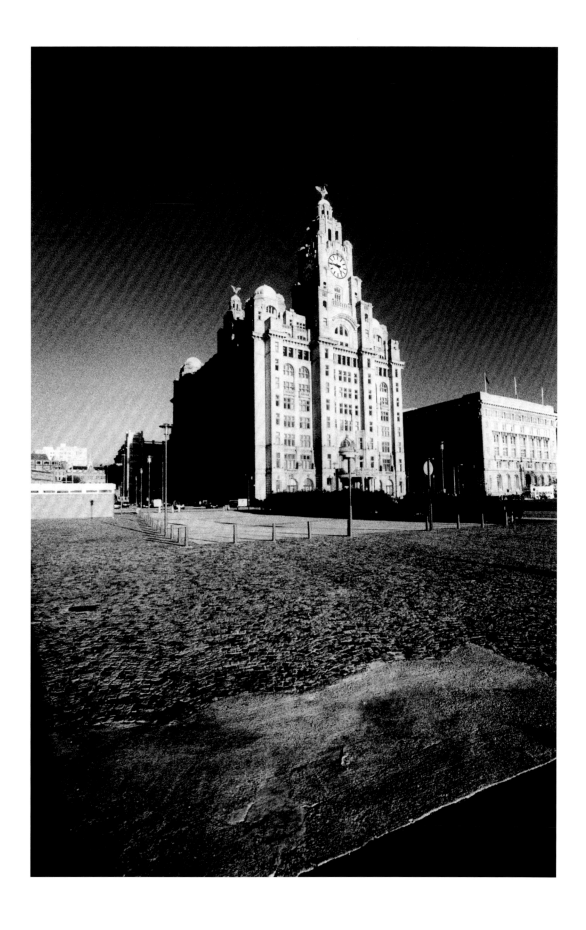

Liver Building : Autumn 2003

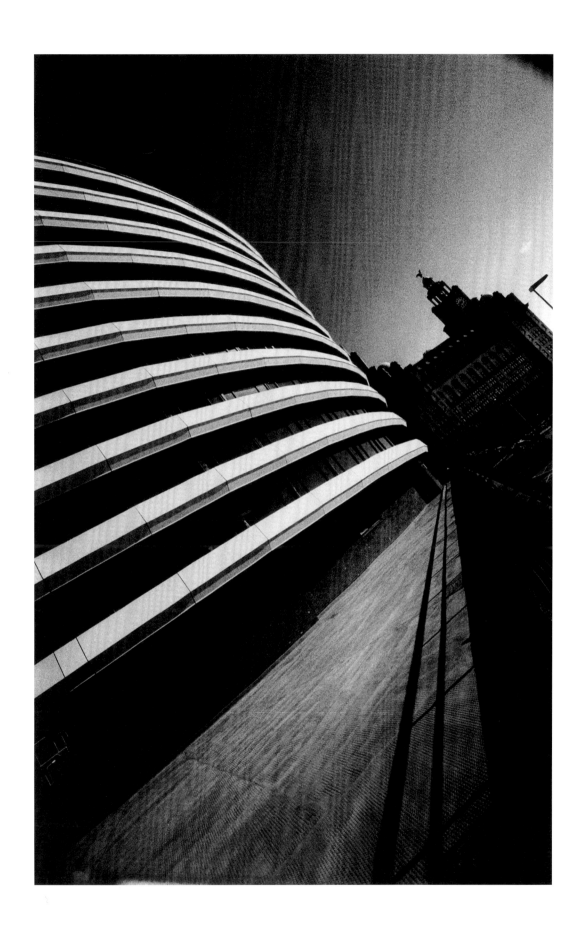

Atlantic Terrace and Liver Building : Spring 2004

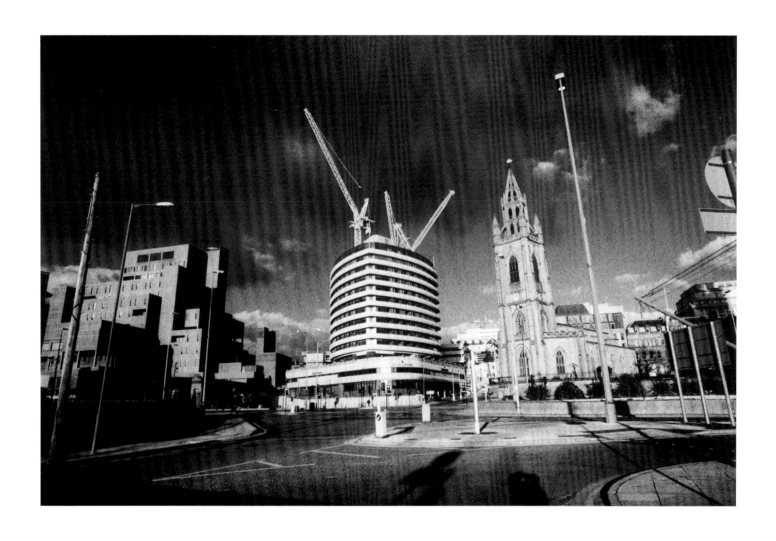

Panorama comprising Royal SunAlliance building, Atlantic Tower Hotel, St Nicholas Church : Winter 2005

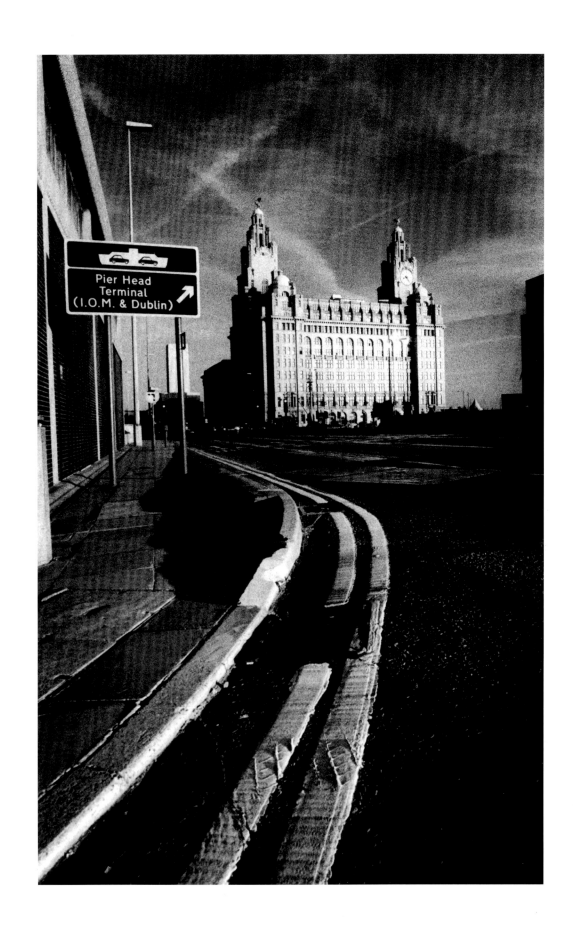

Liver Building from New Quay : Summer 2003

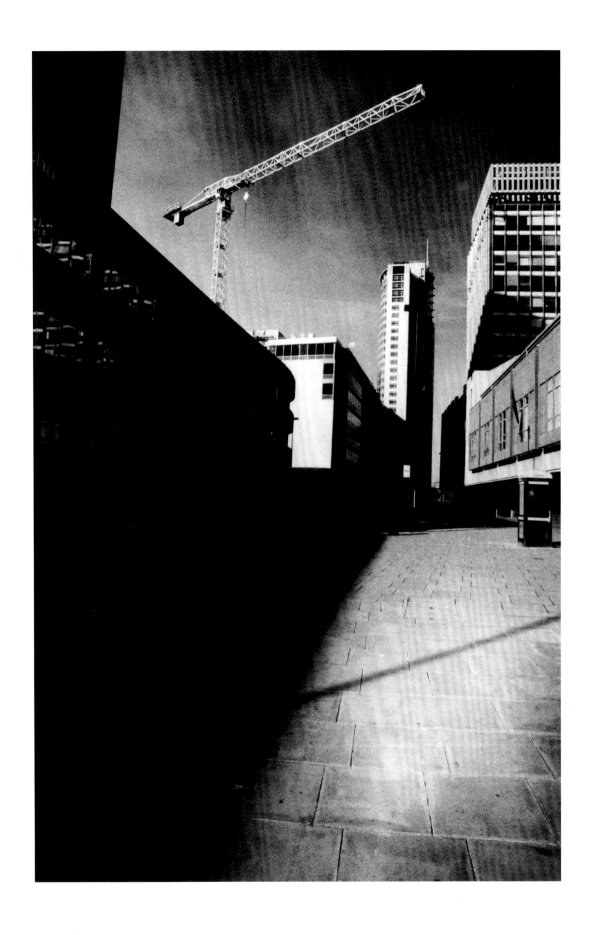

Construction of Beetham Towers, Old Hall Street : Autumn 2003

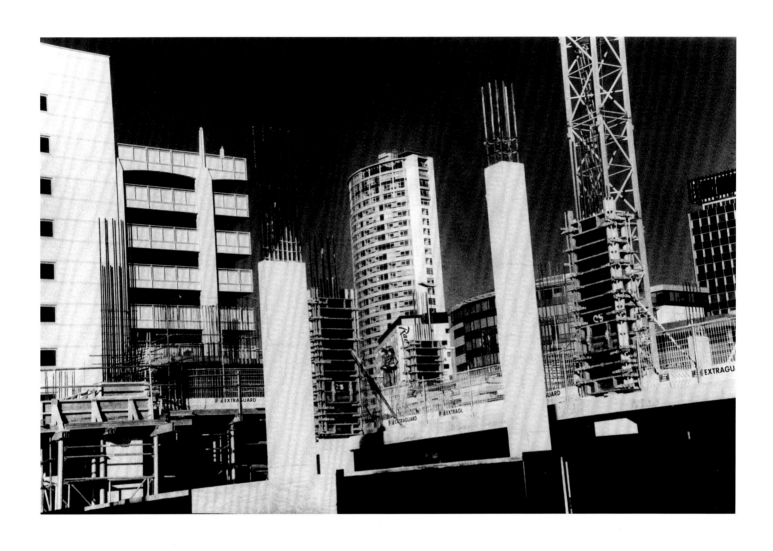

Construction of Hotel Malmasion by Princes Dock : Autumn 2005

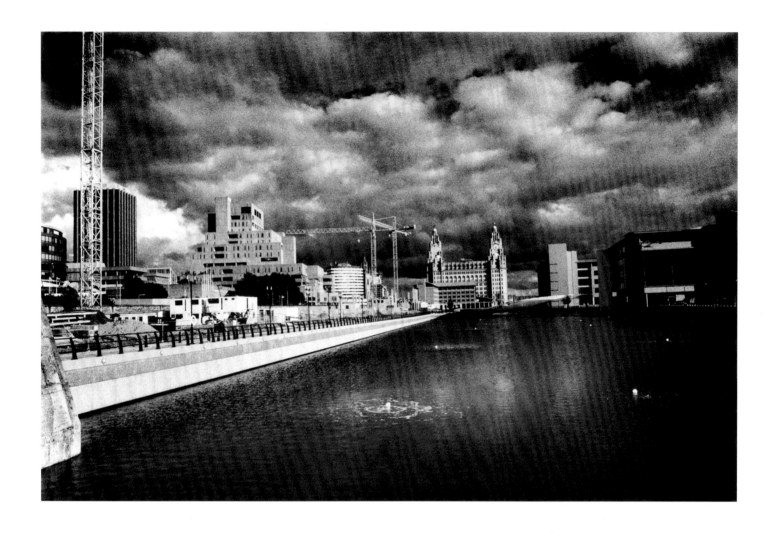

Development of Princes Dock : Summer 2004

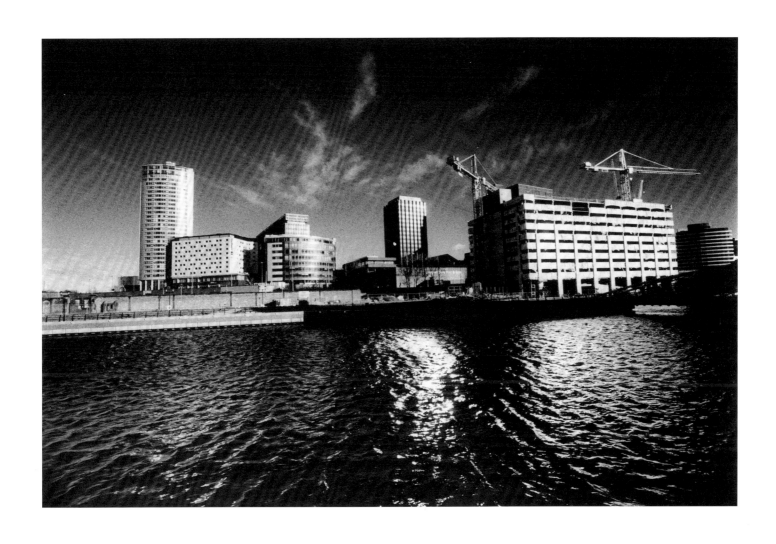

Princes Dock panorama : Winter 2005

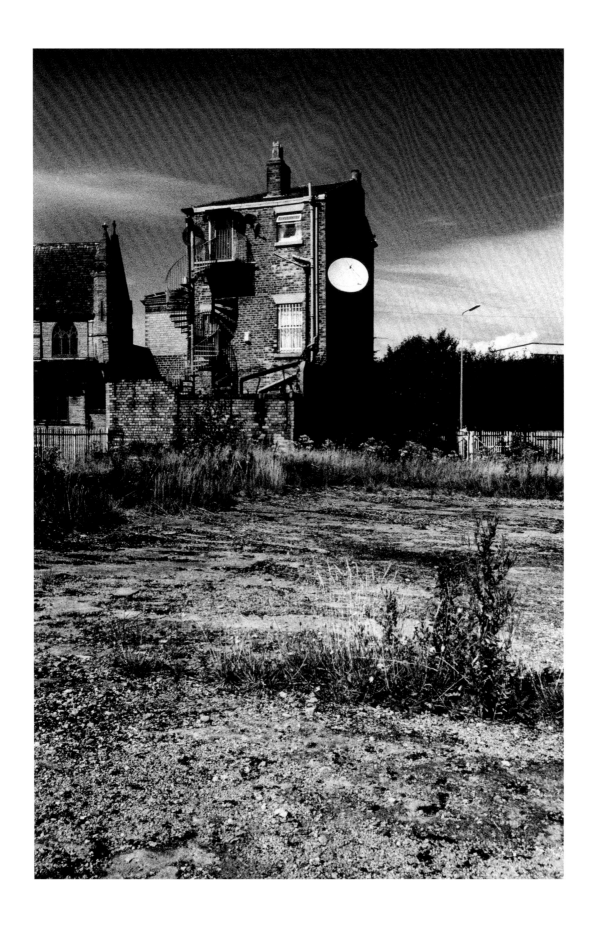

Back of Smith Street [L5] : Summer 2001

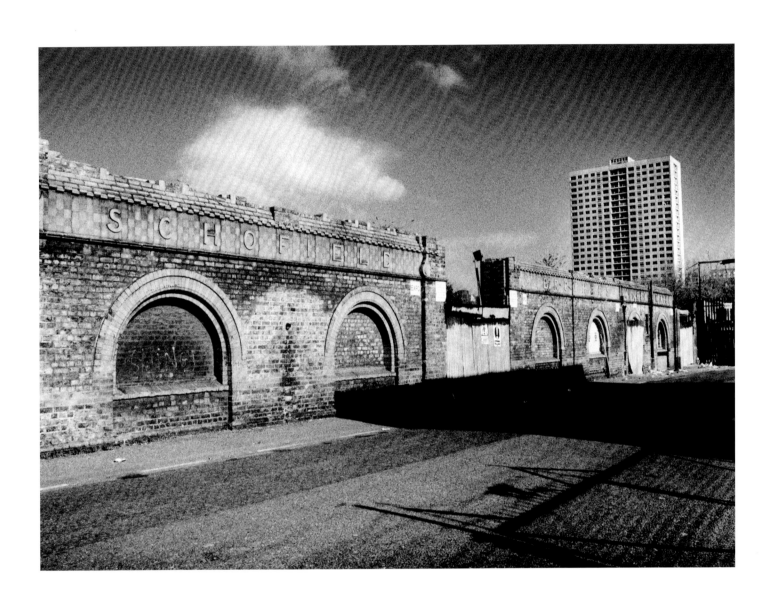

Old Schofields Lemonade factory, near Great Homer Street : Winter 2005

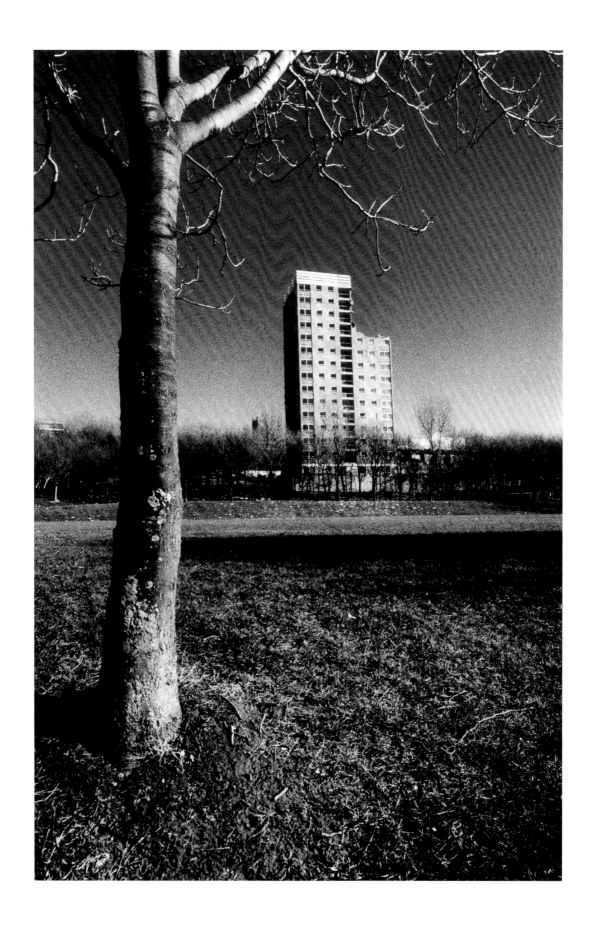

Demolition of tower block of flats, Everton Heights : Winter 2003

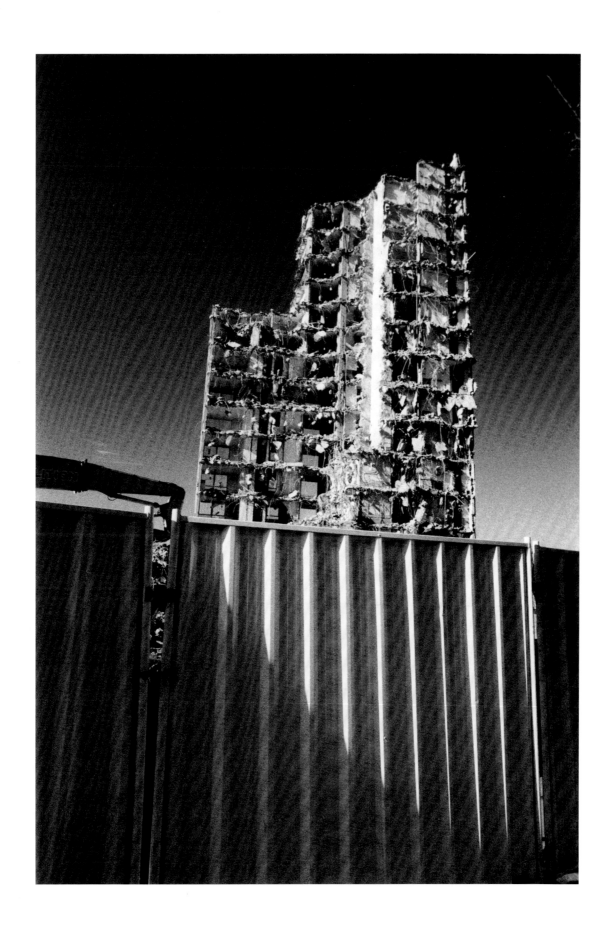

Demolition of tower block of flats, Everton Heights : Winter 2003

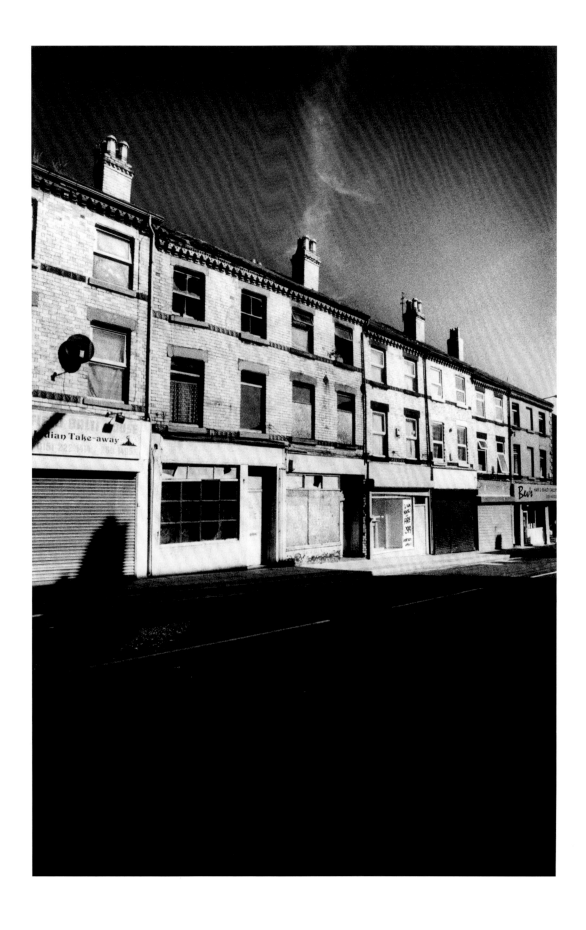

Breck Road : Summer 2004

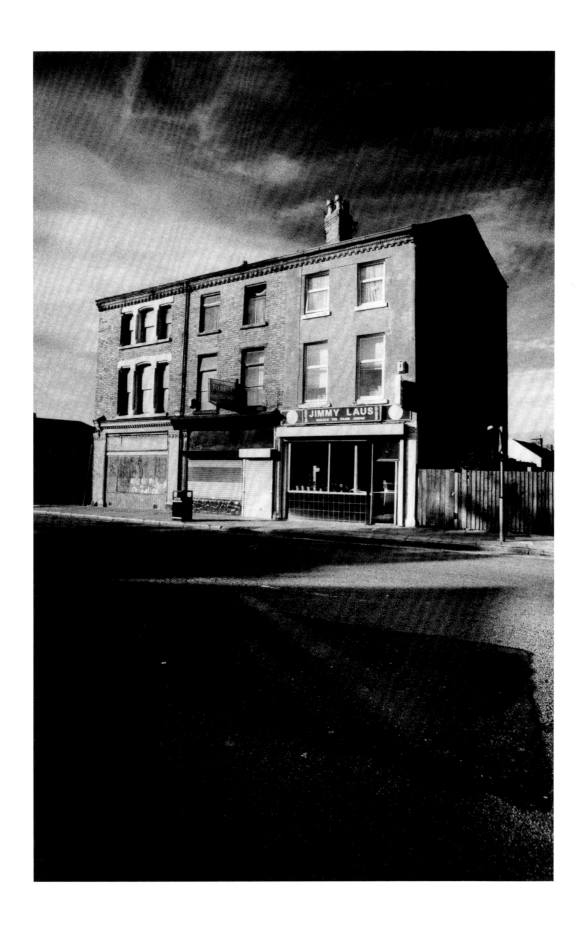

Breckfield Road North : Summer 2004

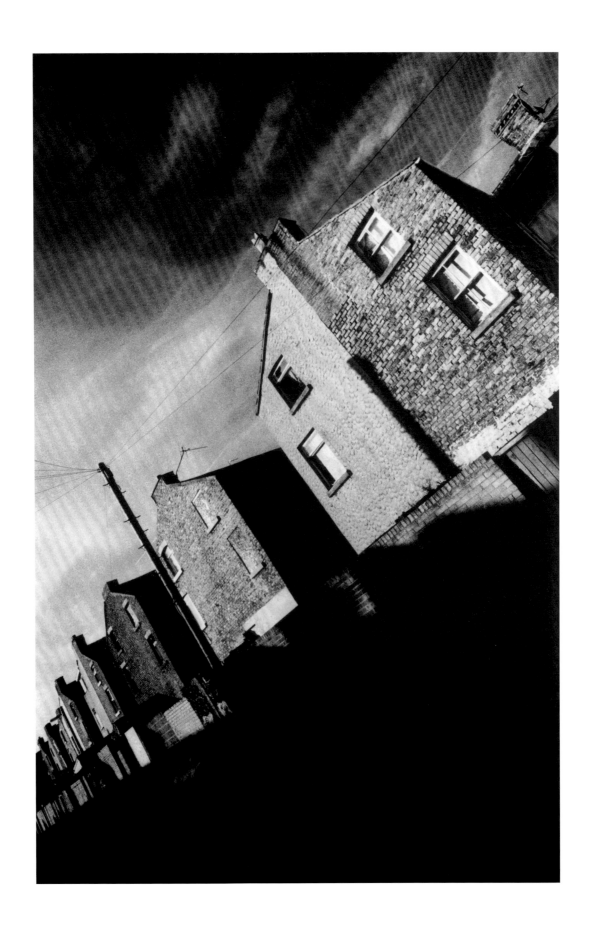

Back alley near Liverpool football ground : Summer 2004

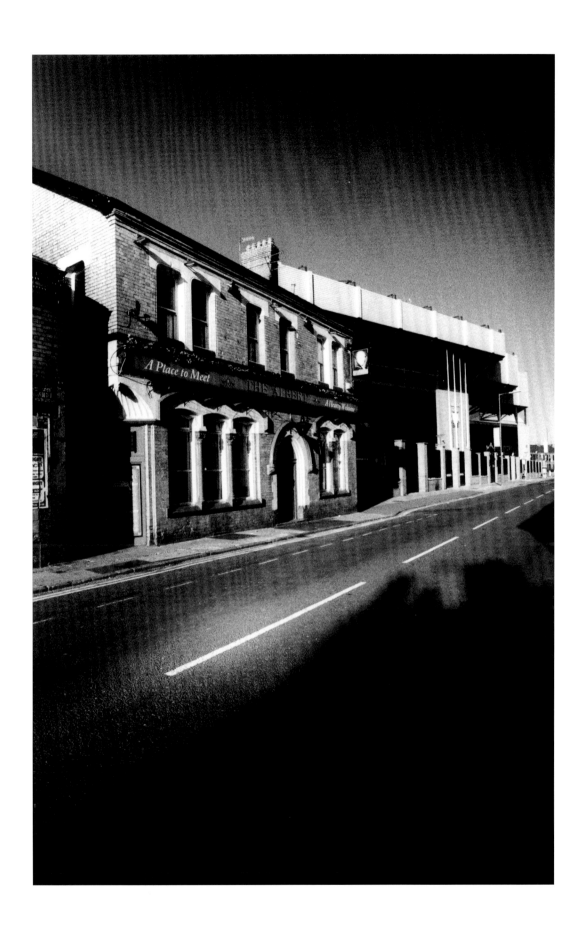

The Albert Public House, by Anfield, LFC : Summer 2004

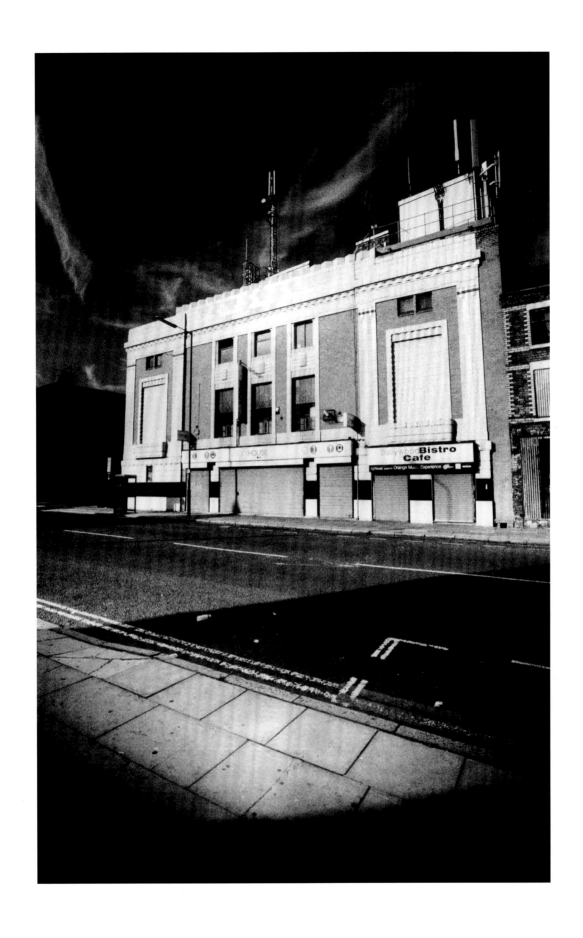

Converted cinema, Oakfield Road, Anfield : Summer 2004

contributors

Alan McKernan

Alan McKernan teaches photography at Liverpool Community College. He specialises in the traditional medium of silver-based black & white photography, combined with specialist hand-printing techniques. He has been documenting the changing face of Liverpool since 2000.

Joseph Sharples

Joseph Sharples is a researcher in the School of History at the University of Liverpool. He was Assistant Curator of Fine Art at the Walker Art Gallery, 1990-2001, and wrote the Pevsner Architectural Guide to Liverpool, published by Yale University Press in 2004.

Matthew H Clough

Matthew Clough has worked for the University of Liverpool since 1996. He has undertaken a number of roles, including Exhibitions Curator and Curator of Art Collections. He became Director of Art & Heritage Collections in January 2006.